IMPRESSIONISM

IMPRESSIONISM

Mark Powell-Jones
with notes by Philip Cooper

Φ

Phaidon Press Limited
2 Kensington Square, London W8 5EZ

First published 1994
© Phaidon Press Limited 1994

A CIP catalogue record for this book is available from the
British Library

ISBN 0 7148 3053 4 Pb
ISBN 0 7148 3219 7 Hb

Printed in Singapore

Cover illustrations:
Front: Edouard Manet, *Monet Painting in his Floating Studio*, 1874
(Plate 23)
Back: Edgar Degas, *The Dance Class*, 1873–5/6 (Plate 21)

The publishers would like to thank all those museum authorities and
private owners who have kindly allowed works in their possession to
be reproduced.

Impressionism

The Origins of Impressionism

The roots of Impressionism can be found in a number of different and apparently conflicting movements in thought and art. First and foremost, it sprang from the tradition of naturalism in the visual arts, from the idea that the painter's job is to produce a convincing image of reality. This apparently simple aim has within it an unresolved ambiguity: is the convincing image one that shows the world as the artist knows it to be, or is it one that shows it as he and others perceive it? Primitive societies, knowing that a man has two eyes, tend to demand that his image should always have two eyes as well. In the years leading up to the Renaissance, however, painters began to move towards painting scenes not as they knew them to be, but as they would appear from a particular viewpoint, so that a man in profile was shown with only one eye, and a man in the foreground was bigger than a castle in the background. The public, in short, was trained to accept the use of perspective, a convention that came to seem so natural that Europeans were quite surprised to find that to people outside their tradition a drawing of a table in perspective simply looked like a drawing of a crooked table. The achievement of the Impressionists was to match the revolution that occurred in the Renaissance with regard to the representation of form with a revolution in the representation of colour. For the first time in the history of art they made a prolonged and concerted attempt to paint objects not the colour that we know them to be but the colour that we see them.

Naturalism was not, however, popular with the art establishment in France and elsewhere, which believed that mere problems about the representation of reality had been solved once and for all during the Renaissance. That being so, it was felt that the sacred duty of the artist was to search for and express in his painting the ideal, to bring into people's lives precisely that which is lacking in reality. Now traditionally the artist, like any other craftsman, had been at the service of the society in which he lived. Naturalism had flourished only when, as in seventeenth-century Holland, those who paid for the paintings were interested in the representation of reality. The extraordinary decision of the Impressionists to produce work for which not only was there no strong demand, but towards which the public felt active hostility and contempt, can be explained only by reference to the effect of Romanticism.

The Romantics were not in the least concerned with mundane reality but they did have strong and influential views on the relationship of the individual to society and to nature. They expressed what were, in terms of established European thought, two revolutionary views. The first was that an individual's personality was of an importance that transcended any limitations imposed by his place in the social hierarchy, and that it was not only permissible, but in some way rather heroic, to hold views that went clean contrary to

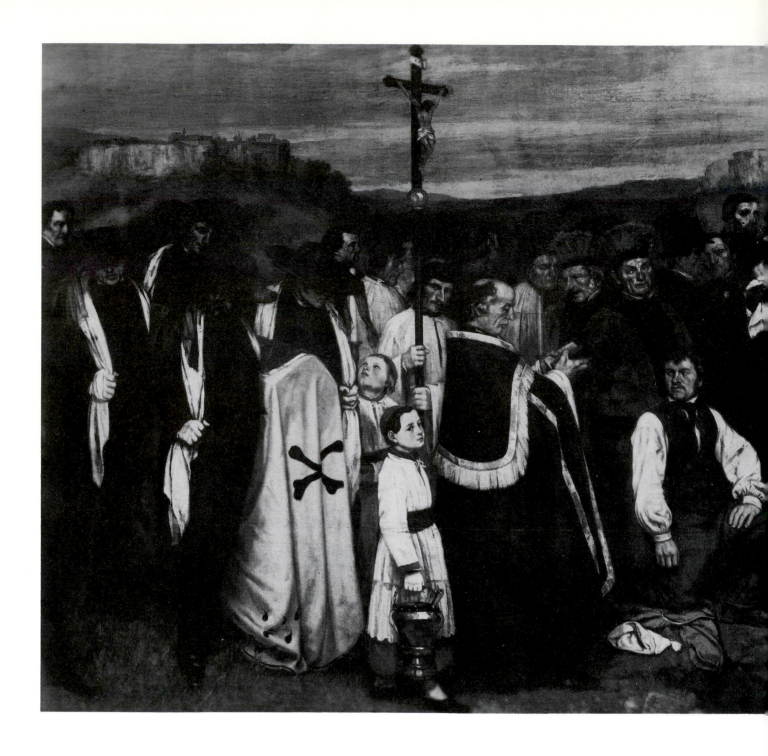

Fig. 1
Courbet
Burial at Ornans
1850. Oil on canvas,
312 x 663 cm. Paris,
Musée d'Orsay

accepted opinion. From this followed the concept of the noble outcast, misunderstood and mistreated by society, which made being heroic in this sense a position that previous generations would have regarded as both pitiable and laughable. The second was that nature is admirable not, as previous generations had tended to believe, in so far as it had been ordered by man, but in and for itself. So, if naturalism provided a tradition and an unresolved problem, Romanticism provided an attitude towards nature that made study of it seem desirable, and a self-image for the artist that made it possible for him to pursue it even in the face of public hostility.

Courbet and the Barbizon School provided a third essential element in the birth of Impressionism – an actual, living example of painters who had already set out on such a path. Courbet, who in his art and opinions totally rejected both Romanticism and Idealism, was nevertheless the epitome of the Romantic outcast. In works like

Burial at Ornans (Fig. 1) he had not only taken it upon himself to represent ordinary people (who were about as likely to be found in the canvases of respectable painters as in the drawing rooms of polite society), but also outraged even those who were prepared to accept the sentimentalized poverty of the peasants in the work of a painter like Millet, by showing the peasants as they actually were. Such outrage derived from a belief (shared equally by Courbet and the régime, which he as a revolutionary republican loathed) that to allow that common people were a fit subject for art was to imply that they were fit to govern, and that to show up official art as a sham was to imply that the structure of the régime was one too. From Courbet's example artists learnt that the representation of reality was not simply a technical exercise, but rather an activity with considerable social and intellectual implications. They also learnt that it was possible for an artist to take on society and win at least widespread notoriety,

Fig. 2
Monet painting at
Giverny with his step-
daughter Blanche
Hoschedé-Monet,
c.1915

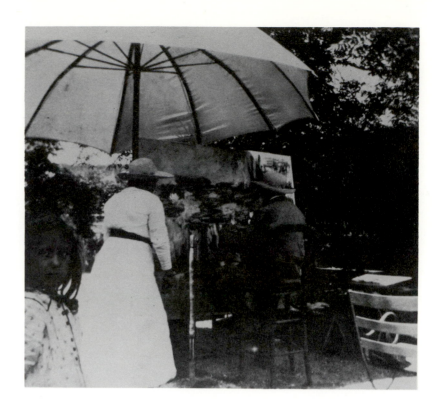

and the admiration of a select few.

The Impressionists were not, however, much attracted by Courbet's subject-matter or technique. It was Corot and the Barbizon School who provided examples of painters working towards a sincere understanding of nature. Their work did not in any sense represent a revolution in the history of landscape painting. Turner had demonstrated a more daring approach to problems of atmosphere, by painting the effects of light and mist, and even the Barbizon School's emphasis on work in the open air had been anticipated by the English landscape school. Yet it was these painters that the Impressionists looked up to with admiration, and it was from them and, in Monet's case, Boudin and Jongkind, that they took their subject-matter and approach.

The Early Years

Monet was, from the beginning, the dominant force in the development of Impressionism. It was his profound love of nature and his obstinate belief in the importance of finding the most perfect way of rendering its appearance on canvas that set and kept his friends on the path towards Impressionism, and it was he who continued to develop it with the greatest tenacity right to the end of his life.

Claude Monet was born in 1840 and grew up at Le Havre in Normandy. His talent, rather ironically in view of the fact that his later work showed little or no interest in the human face, first showed itself in juvenile caricatures. These were so successful that he was able to sell them in the shop of a picture-frame maker, and there in 1858 he met Eugène Boudin. Although Monet initially detested the older artist's seascapes he finally accepted his invitation to go sketching in the country. It was in the country, he later recalled, that 'My eyes were finally opened and I really understood nature: I learned at the same time to love it.'

In 1859, at Boudin's suggestion, Monet went to Paris. He decided to remain there in order to become a painter but, with a radical arrogance

almost unbelievable in a half-educated young provincial, declined to take what was then the only recognized training at the École des Beaux-Arts. Instead, he continued to study landscape and started to draw the nude at a private establishment, the Académie Suisse. In 1860 he was drafted to Algeria as a conscript in the French army.

In 1862 Monet, who said later that 'the impression of light and colour' that he had received in Africa 'contained the germ of my future researches', became ill and was bought out of the army. At home in Le Havre in the summer of that year he met the Dutch painter, Johan Barthold Jongkind. 'From that time', Monet recalled, 'he was my real master ... it was to him that I owe the final education of my eye', and indeed Monet's land- and seascapes of the 1860s are closer in their boldness and solidity to Jongkind's than to Boudin's relatively timid work (Fig. 3).

Monet's father insisted that if he wanted an allowance he must enter the studio of a successful painter. Reluctantly he agreed, and went to work under Charles Gleyre, the most popular and lenient of the academic teachers. There he met Frédéric Bazille, a rich young man from the south of France, Alfred Sisley and Auguste Renoir.

Renoir was unique among the Impressionists in coming from a poor family, and in having grown up in the poorer quarters of central Paris. He was apprenticed as a painter of porcelain, and when the business closed down, he managed to earn good money by painting blinds and mural decorations in cafés. By the age of 21 he had earned enough to keep himself as an art student, and passed the entrance exams for the École des Beaux-Arts with high marks. He settled down to work in Gleyre's studio, where, as he later recalled, 'I stayed quietly in my corner, very attentive, very docile, studying the model, listening to the master.' Indeed had it not been for Renoir's unacademic love of bright colours and the disturbing influence of Monet, he and his fellow pupils – Sisley, who intended to compete for the Prix de Rome, and Bazille – all might have become successful establishment painters.

In 1863 Henri Fantin-Latour, impressed by the fluency of Renoir's talent, first led him out of the studios. 'You can never copy the masters enough', he told him, and sent him off to the Louvre. Monet preferred a different avenue of escape and set out with Bazille to paint in the

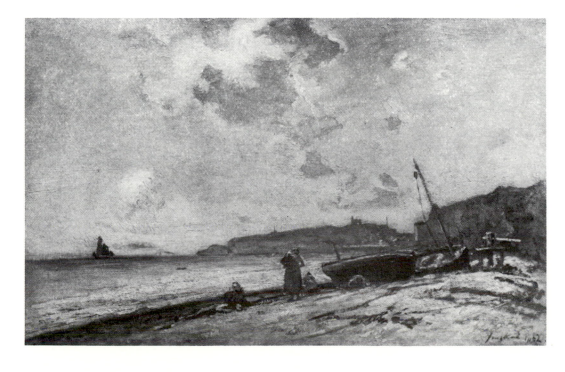

Fig. 3
Jongkind
Sainte Adresse
1862. Oil on canvas,
27 x 41 cm.
Private collection

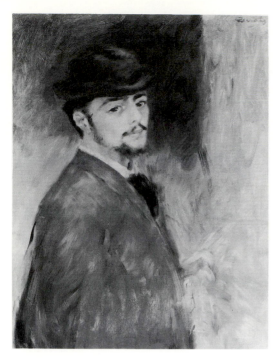

Fig. 4
Renoir
Self-portrait
1876. Oil on canvas,
73 x 56 cm. Cambridge,
MA, Fogg Art Museum

country, at Chailly on the edge of the Fontainebleau forest near Barbizon. In the following year he went again to Chailly, this time bringing with him Renoir and Sisley as well as Bazille. This was their introduction to nature, and, under the influence of Monet and of Diaz, a Barbizon painter with whom Renoir made friends, they began to develop an interest in landscape.

Back in Paris it was the work of Edouard Manet that exerted the greatest influence on the young painters. Manet, after the considerable success of his *Guitar Player* at the Salon of 1861 was refused, along with a large number of other painters, at the Salon of 1863. The resulting outcry led to the opening of the Salon des Refusés, at which he showed a painting entitled *Le Déjeuner sur l'Herbe* (Plate 2). This, by showing naked women, not in a safely allegorical context, but having a picnic in the country with men clothed in contemporary dress, caused considerable scandal. It also identified Manet in the public's mind as the leader of radical tendencies in art.

Le Déjeuner sur l'Herbe interested Monet, not for the scandal it caused, but because it highlighted, although failed to solve, the problems of integrating figures into landscapes painted in the open air. These problems he set out to solve in 1865 and 1866 in a series of studies for a painting to which he gave the same title.

In the late 1860s, Monet and Renoir also became interested in painting scenes of Paris. To an extent these also reflected the influence of Manet, who in the *Music in the Tuileries* (Plate 1) had provided the most successful answer yet to Baudelaire's plea for a 'painter of modern life'. They also show the effect of the work of photographers like Nadar. For in these cityscapes, as in photographs, scenes are taken from unexpected angles, and people are represented as stick-like figures, more part of the urban scenery than individuals. The programme for the painter of modern life laid out by the literary critics was, however, like all programmes, anathema to the essentially pragmatic approach of the Impressionists. It was left to artists standing rather apart from the mainstream of Impressionism, like Manet himself and above all Degas, to capture the beauty of contemporary Parisian life.

The Development of Impressionism

It was during the years immediately before and after the Franco-Prussian War and the Commune that Monet, Renoir and Pissarro developed that approach to the representation of open-air scenes that came to be termed 'Impressionism'.

Fundamental to the development of Impressionism was the belief that the sensation received in the open air, before the motif, was of primary importance, and that to work up a landscape in the studio was inevitably to dull and even falsify the impression obtained on the spot. Monet, following the example of Boudin, was, as we have seen, the first of the group to realize the virtues of this approach. It was he who introduced his friends to it and who maintained their faith in its value. As a result of working in the open air, Monet and his friends became increasingly convinced that the sombre coloration and brown shadows sanctioned by traditional landscapists were untrue to nature. In an effort to purify and brighten his colours Monet, following the example of Manet, began to prime his canvas with a white ground instead of with the sombre base used by even so radical a painter as Courbet. Renoir, with his innate love for bright colours, and Pissarro, who proclaimed that it was necessary to use only the three primary colours and their derivatives, also moved towards a brighter palette.

Fig. 5
Photograph of Manet
by Nadar, c.1865.

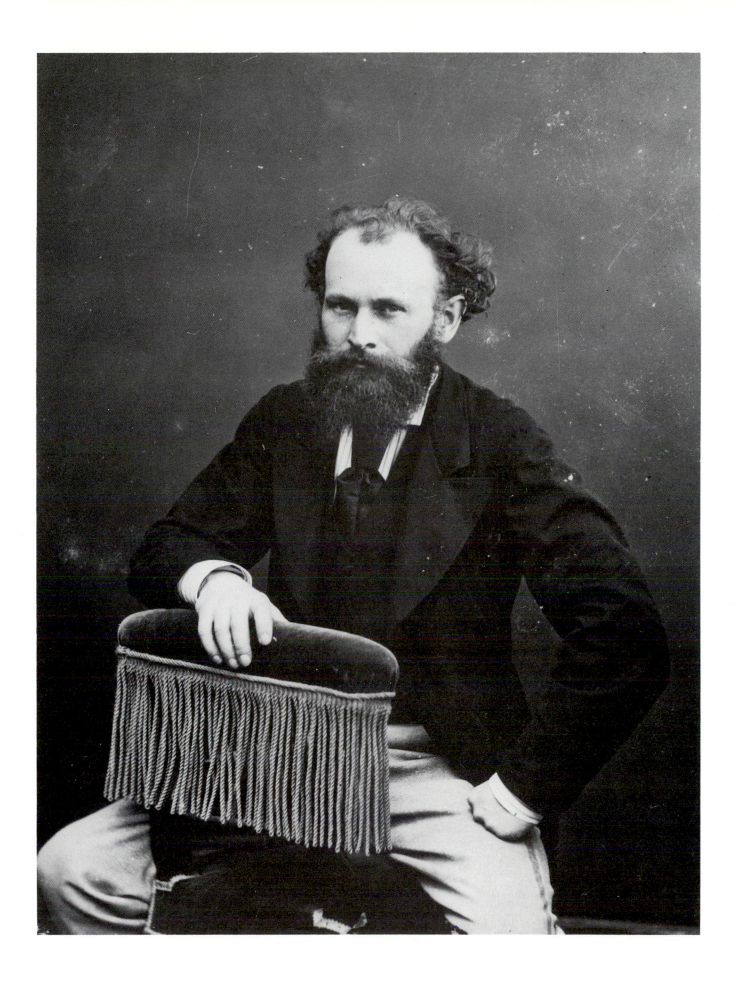

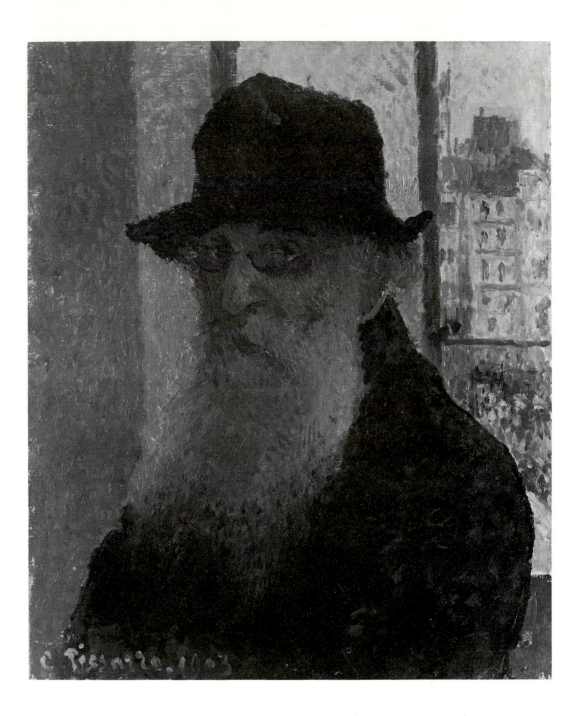

Through their close and continuous observation of nature, Monet and Renoir became aware that shadows are in fact coloured by the objects around them, and in Monet's *Terrace at the Seaside* and Renoir's *Lise*, both of 1867, this knowledge is already apparent. In order to develop it they liked to work on snow scenes, for snow being pure white, and thus colourless, has the advantage of showing up with particular clarity the colours that are reflected on to it.

In the struggle to represent nature as it is perceived, rather than as we know it to be, Monet, Renoir, Pissarro and their friends tried to be as humble as possible before it. They wanted to allow nature to speak through them rather than impose their preconceived ideas on it. Paintings must, they felt, record not, for example, a tree, a winding road and some rooftops, but those impressions received from them, which would in turn be interpreted by the viewer in the same way that he would interpret the impressions received directly from the scene. In the past a painter interpreted and then painted the impressions he had received as objects. Now the painter would renounce the act of

interpretation and paint only the impression.

In an effort to rid themselves of the tendency to think in terms of delineating objects with lines, which resulted from the artist's pre-emptive interpretation of what he saw, the Impressionists needed to select subjects to which a linear approach was clearly inapplicable. As snow showed up the impossibility of the colourless shadow, so water, mist, masses of blossom, or grass rippling in the breeze showed up that of the outline. Working at La Grenouillère, a popular bathing place near Paris, and, after the war, at Argenteuil, Monet and Renoir grew close to each other both in style and subject-matter, as shown by Renoir's *La Grenouillère* (Plate 10) and *Path through the Tall Grasses* and Monet's *Boats at Argenteuil* and *Poppy Field at Argenteuil* (Fig. 7). Increasingly, in the attempt to represent ever-changing reflections in the ripples of the water they preferred to use short and even comma-like brush strokes. Using these to place small, pure dabs of colour side by side, they were able to create on canvas the vibrant interplay between different colours that direct as well as reflected light produces in nature. Through this technique they were able to take as their subject not the objects themselves, but the light and atmosphere that surround objects, thereby giving their works a unity that was quite independent of composition.

The development of Renoir's and Monet's work was observed and appreciated by their friends. After Pissarro had met and painted with Monet in London during the war, his work, such as *Lower Norwood*,

Fig. 7
Monet
Poppy Field at
Argenteuil
1873. Oil on canvas,
50 x 65 cm. Paris,
Musée d'Orsay

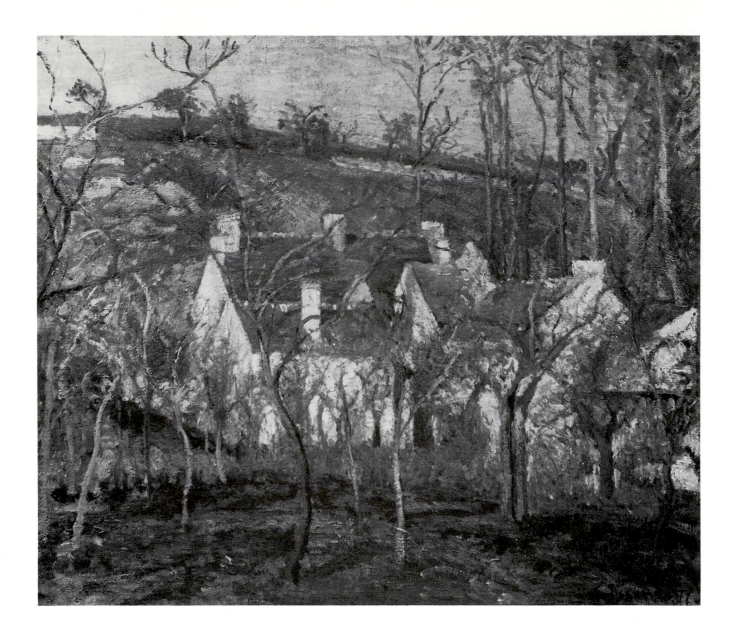

Fig. 8
Pissarro
The Red Roofs (Côte
St Denis at Pontoise)
1877. Oil on canvas,
54 x 65 cm. Paris, Musée
d'Orsay

London, Effect of the Snow, Entrance to the Village of Voisins (Plate 16), *Village near Pontoise*, and *The Red Roofs* (Fig. 8) moved strongly in the direction that Monet's work had taken, though retaining a feel for construction and for the solidity of things that was his own. Sisley and Berthe Morisot also moved away from the influence of Corot toward a fully Impressionist approach, as shown by Sisley's *L'Ile de Grande-Jatte* and *The Road Seen from the Chemin de Sèvres*, and Morisot's *Field of Corn* and *In the Garden*, and even Manet when he visited Monet at Argenteuil in 1874 followed their example.

The Impressionist Exhibition

The great advances towards a new style of painting on the one hand, and their increasing age (most of them were in their thirties) and family responsibilities on the other, made it seem more and more imperative to the Impressionists that their work should be seen, and preferably bought, by the public. In 1869 and 1870, it is true, the Salon jury had been elected by all those who had ever had paintings accepted at the Salon, and in 1870 all save Monet and Cézanne had had at least one painting accepted. But a powerful reaction to any kind of radicalism followed the excesses of the Commune and took a strong hold on the world of art in the early 1870s. The election of the jury was once again restricted to those who had won medals, and Courbet's works were denied exhibition on purely political grounds.

Courbet's 'Pavillon de Réalisme' at the Exposition Universelle of 1855 and his and Manet's private exhibitions at the Exhibition of 1867 had already given Monet the idea of holding a separate show. In response to an article by Paul Alexis, published in May 1873, he relaunched the idea, and it was well received by his friends. Pissarro, as an anarchist, proposed a complicated and bureaucratic co-operative on the lines of the Union of Bakers at Pontoise. Renoir, a believer in law, who nevertheless hated rules, defeated this proposal. Instead a company was formed whose founding members included Monet, Renoir, Sisley, Degas, Morisot and Pissarro. They decided to hold the exhibition in premises lent by the photographer, Nadar. Degas, keen to ensure that the group was not seen as one of unsuccessful, revolutionary, landscape painters, approached a number of older artists, while Pissarro incurred his displeasure by inviting Cézanne. Manet, who had enjoyed considerable success at the Salon of 1873 with his *Bon Bock*, and who believed that his dream of official recognition might soon be realized, refused to participate.

The exhibition opened on 15 April, 1874. Among Monet's works there was a view of Le Havre harbour in the morning mist, which he called *Impression: Sunrise* (Plate 17). Reviewers seized on this – Castagnary, for example, wrote: 'If one wants to characterize them with a single word that explains their efforts, one would have to create the new term of Impressionist. They are Impressionists in the sense that they render not a landscape, but the sensation produced by a landscape.' Other reviewers were, on the whole, less friendly and tended either to pass the exhibition over in silence or to mock the efforts of the artists represented in it.

Few people came to see the show, and fewer bought pictures. In short, it was not a financial success. The company had to be wound up, and the sale held to clear the debt was a disaster. Those members of the group without a private income and with a family, Monet and Pissarro in particular, were on occasion so desperately poor that they could not even afford to buy paint or canvas.

Yet somehow they continued to work. Monet as always pursued the most difficult and evanescent effects of light, by the river, in the fields, or in the steam rising from the railway engines, in 1877, in the Gare St-Lazare. Renoir, besides his landscapes, found happy inspiration in recording the pleasures of all ranks of Parisian society, as in *Dance at the Moulin de la Galette* (Plate 32) and *The Swing* (Plate 33), and Pissarro applied himself to the effect of the changing seasons of the countryside around Pontoise in paintings such as *Village near Pontoise*, *Harvest at Montfoucault*, *Kitchen Garden and Trees in Blossom* (Fig. 9), and *The Red Roofs*. Morisot produced intimate yet freely handled scenes of family life, and Sisley was inspired to paint some of the most delicate and poetic of Impressionist landscapes, such as *Flood at Port-*

were present in a particularly acute form during the 1870s.

Fear of change reached such a point in the art world that the jury of the 1878 Exposition Universelle excluded not only the Impressionists but even Delacroix, Millet and Rousseau. In this situation it is not surprising that a group that set out to overturn the accepted canons of taste, mocked the establishment, disdainfully opened a separate exhibition before the Salon, and from 1877 forbade its members to show there, was classed as revolutionary. The *Universal Monitor*, for example, on the grounds of a favourable review in a radical paper, noted that 'the intransigents of art join hands with the intransigents of politics', adding that such an alliance was only to be expected. Yet, though the majority of the group, including Manet and Monet, were left-wing, only Pissarro was positively committed to revolution, and, in the end, only Pissarro, out of political conviction, and Degas, out of pride and disdain, remained committed to challenging the system. Monet and Renoir increasingly felt the need to dissociate themselves from an anti-establishment stance so that, presenting no threat to society, they could at last receive recognition. Renoir indeed actually wrote to Durand-Ruel, before the last Impressionist exhibition (1882) in which he participated, to say that he did not wish to be associated with Pissarro on account of his political ideas, and added that he would continue to exhibit at the Salon to 'dispel the revolutionary taint, which frightens me'.

There was however another even more important reason for the break-up of the Impressionist group. In the 1870s they developed and exploited their solution to the problem that had led them to Impressionism. Having done so, they began to feel the force of Castagnary's criticism of their first exhibition: 'Before many years,' he had written, 'the artists grouped at the Boulevard des Capucines today will be divided. The strong ... will have recognized that if there are some subjects suitable for an "impression" ... there are others ... which are not.' He implied that the stronger artists, having 'perfected their drawing, will abandon impressionism'. By 1883 Renoir, as if haunted by this prediction, felt that he no longer knew how to paint or draw, turned away from Impressionism and began to concentrate on line rather than colour. Pissarro became worried by what he considered to be his 'unpolished and rough execution', and Monet wrote to Durand-Ruel: 'I have more and more trouble in satisfying myself and have come to a point of wondering whether what I do is neither better nor worse than before, but the fact is simply that I have more difficulty now in doing what I formerly did with ease.'

Each of these painters was to find his own way out of this impasse. Sisley alone of the original band continued to paint in a purely Impressionist style right up to his death in 1899. Conscious, perhaps, that he would never be able to surpass the pure joy of his early land- and cloudscapes and the poetic serenity of his studies of rivers and floods, such as *L'Ile de Grande-Jatte* and *Flood at Port-Marly*, he grew increasingly bitter in his isolated and poverty-stricken old age.

Friends and Contemporaries

If the term Impressionist is used strictly, to refer only to the originators and users of a specific technique for transcribing the effects of sunlight on objects in the open air, then only a small proportion of the exhibitors at the Impressionist exhibitions can be so described. Yet, to contemporaries and to the painters themselves, it had a wider signification. Manet, though he used Impressionist techniques only briefly, and never exhibited with the group, was often referred to as

the leader of the movement. Degas was not only uninterested by, but positively opposed to, painting in the open air or even directly from the model. He admired Ingres, considered line of supreme importance and colour a dangerous distraction. Yet, though the mirror image of an Impressionist in his opinions, he was an absolutely central figure in the group.

Edouard De Gas (who later signed himself Degas) was born in Paris in 1834, the son of a banker from a good family who collected the work of Ingres. Until 1862, when he met Manet, who was like himself something of a smart young man about town, Degas seemed set on a conventional career as a history painter. Like Manet, however, he became interested in Baudelaire's idea of the 'painter of modern life'. He found a description of this desired but imaginary creature in a novel by the Goncourt Brothers, *Manette Salomon*, which was published in 1867. 'All ages carry within themselves a Beauty of some kind or other', they wrote. 'There must be found a line that would precisely render life, embrace from close at hand the individual, in particular, a living human, inward line.' In his notebooks Degas outlined plans to explore the possibilities of contemporary life, such as studying musicians with their instruments, cigarette smoke, smoke from steam engines, the naked legs of dancers and cafés at night. In his approach to these subjects he was influenced by Japanese prints – by the care with which Japanese artists placed their subjects in relation to the frame and by their ruthless use of that frame to cut off a scene in the middle of a figure or an object. Photography also has its influence through its ability to capture the unexpected angle and cut a random square out of reality. His interest in modern life led Degas, in the late 1860s, to abandon historical subjects and turn, first to scenes of life on the racecourse, and then increasingly to scenes of theatrical life – of musicians and above all of dancers. In 1874 Edmond de Goncourt visited Degas' studio, recognized the influence of *Manette Salomon* in his paintings of dancers and laundresses, and commented that 'he is the man I have seen up to now who has best captured, in reproducing modern life, the soul of this life.'

In 1876 Degas lost most of his fortune and began to depend on selling his paintings. This financial necessity came into conflict with his unwillingness to part with his work, an unwillingness that arose from a perfectionism that drove him to return to paintings, even after an interval of years, in order to improve or destroy them. Fortunately he found in pastel a medium less formal than oil. In his later years he used it almost exclusively, achieving a freedom, spontaneity and daring in his use of colour that are surprising in an artist who professed to believe in the exclusive value of line.

In the 1886 Impressionist exhibition he exhibited a series of pastels, the 'nudes of women bathing, washing, drying, rubbing down, combing their hair or having it combed'. Of such pastels Degas wrote, 'this is the human animal busy with itself.' He wanted to present the nude not as it 'had always been presented, in poses which presuppose an audience', but in a natural way 'as if you were peering through the keyhole'. It is in works like these (Plate 43) that his fundamental, though hidden, links with Impressionism become apparent.

On the surface Degas was opposed to Impressionism in all things. 'You need natural life,' he told the Impressionists. 'I, artificial life.' They were interested in colour, he in line, they tried to paint on the spot what they saw in front of them, he from

memory in the studio trying to liberate his 'recollections and inventions ... from the tyranny which nature exerts'. But deep down he shared with the Impressionists an interest in fixing on canvas certain fleeting aspects of reality that had never been caught before. His belief in the value of line made him admire Ingres, but unlike Ingres, unlike any of the establishment painters, he replaced composition by selection. With his dancers and his women in milliners' shops, as with his nudes, he did not pose the models, but instead observed them carefully as the went about their business. Then with a miraculous instinct he chose the precise viewpoint, the precise field of vision and above all the precise moment in the seamless continuum of movement, whether of a woman getting out of a tub or of dancers moving across a stage, in which every line is united in perfect harmony.

Degas, thus, can be seen as an Impressionist who realized that to train the hand to transcribe the perceptions of the eye as they were received was, even when Monet took it to its logical conclusion by working on a canvas for as little as ten minutes at a time, inevitably to falsify changes that occur second by second. Instead, he trained his mind to snip from the reel of his visual memory the truly instant impression that satisfied him.

Among those who were influenced by Degas' solution to the impossible dilemma of the naturalist was the young American painter, Mary Cassatt, who said, 'The first sight of Degas' pictures was the turning point of my artistic life'.

Though older than either Monet or Renoir, Cézanne, too, was influenced by Impressionism. He had known Pissarro since 1861, but had taken no part in the development of the Impressionist technique. His work remained largely independent of nature until, in 1872, he went to live with Pissarro in Pontoise. The latter, with his unerring eye for talent and his uncanny ability to bring it out, brought Cézanne into contact with nature and, through that contact, helped him to discipline his powerful and melodramatic imagination. The two artists worked together, sometimes on the same motif, and Cézanne was influenced by the humility of Pissarro's approach to nature, by his technique of using small brushstrokes and by his brighter palette as shown by Pissarro's *The Red Roofs* and Cézanne's *The House of the Hanged Man*. Though in the 1877 Impressionist Exhibition he showed, by entitling two of his watercolours *Impression after Nature*, just how far he still considered himself wedded to the movement, in the 1880s he spent more and more time at Aix, cutting himself off from Paris and increasingly from his friends. There he set himself the task of 'making out of Impressionism something solid and durable like the art of the museums'. Later, to the young painter Émile Bernard he said, 'see in nature the cylinder, the sphere, the cone.' It was his ability to transcend the style of Impressionism, to go to the structure that lies behind visual appearance, and his magically delicate colour harmonies that, by appealing to painters like Picasso and Braque, had a central role in the development of twentieth-century art.

The Late Work of Pissarro, Renoir and Monet

In the early 1880s Pissarro had, like Cézanne, begun to look for a way forward from Impressionism. In 1885 he met a much younger painter, Georges Seurat (born 1859). Seurat, though influenced by the Impressionists, whose technique he adopted in his early oil

sketches from nature, had exhibited an extraordinarily original work, *Bathing at Asnières*, at the first exhibition of the Society of Independents in 1884. This continued, to the full, the classical solidity and structure that Pissarro, like Renoir, felt to be lacking in Impressionism. Seurat went on to develop a theory that if, instead of producing a particular tone by mixing colours on the palette, the painter applied dots of pure colour on canvas in the correct proportion, then at the right distance the dots would fuse to produce the desired tone by optical mixture (as they do for example in a colour reproduction, which is made up of minute dots of primary colours). This optical mixture would, he believed, produce clearer and more vibrant colour than could be obtained by mixture on the palette.

This theory, called Divisionism, combined with a Pointilliste technique, offered the perfect antidote to the 'unpolished and rough execution', which had been worrying Pissarro, and a progressive and scientific approach to painting that very much accorded with his political inclinations. Though already in his fifties, Pissarro plunged with enthusiasm into the new technique, explaining to Durand-Ruel that he sought 'a modern synthesis by methods based on science'.

In 1886 he secured Seurat's aid and Signac's participation in the last Impressionist exhibition. But despite the artistic success of Seurat's works like *La Grande-Jatte*, which was shown there, or the *Port of Honfleur*, Pissarro was unable to follow him into the wilder reaches of his theories about the emotional value of different types of line. Instead, feeling increasingly restricted by the impersonality of the Pointilliste technique, he abandoned it in 1890 and returned to further exploration of the possibilities of Impressionism.

Renoir, like Pissarro, felt in about 1883 that he 'had gone to the end of Impressionism'. In an effort to overcome the feeling that he no longer knew 'how either to paint or to draw' he began to value line rather than colour and returned to studying the art of the past. He concentrated on painting nudes and portraits rather than landscape, and having gone through a period of rigid classicism, emerged into an enormously decorative, though sometimes rather facile, late style, which was a conscious attempt to develop the tradition of eighteenth-century French art. 'Nature', he said, 'brings one isolation. I want to stay in the ranks.'

Monet also became deeply dissatisfied with his art in about 1883 but, unlike Renoir and Pissarro, he never really wavered in his belief that Impressionism was the right path. As a result, his painting develops with a single-minded logic that is lacking in the other artists' work.

In his depictions of the countryside around his home at Giverny, in the Seine valley, Monet became increasingly concerned that he should not falsify his impression of a scene by continuing to work on it when the light had changed. According to a journalist who watched him at work this meant that he was frequently unable to spend more than an hour on any particular canvas. It was perhaps a natural consequence, that instead of lugging canvases and easel to a new spot every few minutes, he started to paint the same scene under different conditions of light. He thought that the grainstacks, which he first chose to study in this way, would need only two canvases, one for cloud and one for sun, and was amazed that he had to keep sending his step-daughter back for more canvases as the light changed. What is certainly true is that in the

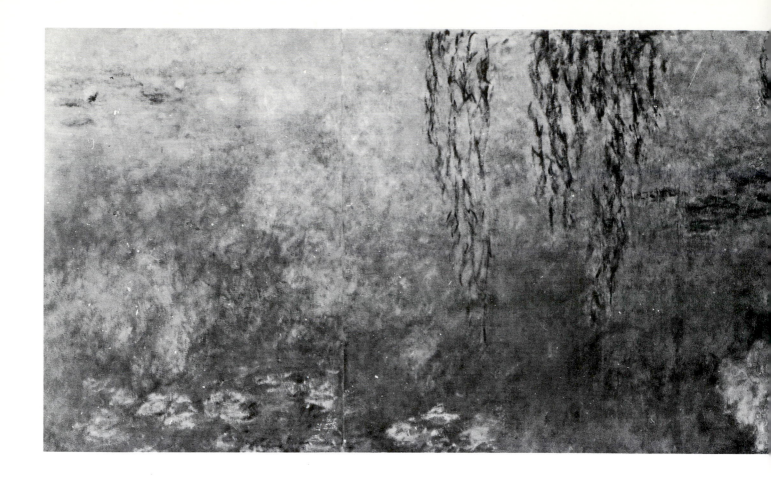

succeeding series, of poplars by the river, of Rouen Cathedral, London, Venice, and above all the water garden which he had created in the grounds of his home, he became increasingly concerned with what he called 'instantaneity', the impression of an instant, and so he worked on ever increasing numbers of canvases at the same time. By 1897, when he was working on the *Morning on the Seine* series, he had fourteen canvases by him, in the open air, ready to switch from one to the other as the light changed.

John Rewald has written of this approach to the fundamental problem of Impressionism that Monet's 'eyes, straining to observe minute transformations, were apt to lose their perception of the whole', and it is true that, in his unswerving dedication to one idea, he did train himself to become unaware of form. Such an intention is implicit in his remark that he wished he had been born blind and then gained his sight, for by this he meant that only a person who has never seen can transcribe undifferentiated visual sensations without being unconsciously influenced by what he knows – that a certain set of sense impressions signifies a tree, another set a house and so on.

In his search for the instant impression and. the perfect transcription of it Monet had, paradoxically, to abandon some of the dogmas of Impressionism. The selection of the right motif for the series paintings was of the greatest importance, and in the end he created the perfect motif, the water garden, artificially. Increasingly, paintings that were begun on the spot were finished in the studio, indeed it would have been impossible to paint the vast *Nymphéas* series (Fig. 10) outside it, and it must have begun to seem to Monet, as to Degas, that the truest image was the one that stayed in the memory.

These moves were not so much breaks with Impressionism as

Fig. 10
Monet
Nymphéas
c.1916-26. Oil on canvas,
200 x 425 cm. Paris,
Orangerie, right panel,
Room II

necessary developments of its technique in order to come nearer to its goal. Another natural development was that, particularly in the series paintings, the Impression became the subject, and the motif merely the means to it. The late paintings work on two levels. From a distance they are astonishingly accurate representations of parts of reality; it seems, for example, almost impossible for Monet to have captured on canvas a scene reflected in water through which waving plants are visible. From close to the paintings are a maze of brushstrokes that seem to have been applied with a view entirely to their abstract relation one to another.

As Monet grew older he became more interested in the painting as object rather than as representation, and indeed, in the end, when his sight no longer allowed him to stand back and see the whole, as he used to do, the immediate surface became of paramount importance to him. The late paintings, which have inspired twentieth-century artists from Kandinsky to the Abstract Expressionists, represent the final paradox of Impressionism. At the moment when Monet after a lifetime of struggle came nearest to being able to transcribe his impression of nature onto canvas he was also on the verge of abandoning the impression. His last paintings seem about to break through to the ultimate naturalism – the point at which the paint in its own right becomes more important than what it represents, so that, at last, the picture is exactly what it seems to be.

Select Bibliography

BOOKS

Steven Adams, *The World of the Impressionists*, London, 1989

Kathleen Adler, *The Unknown Impressionists*, Oxford, 1988

Kathleen Adler, *Manet*, Oxford 1986

Kathleen Adler and Tamar Garb, *Berthe Morisot*, Oxford, 1987

Alice Bellony-Rewald, *The Lost World of the Impressionists*, London, 1976

Bruce Bernard, *The Impressionist Revolution*, London, 1986

Maria and Godfrey Blunden, *Impressionists and Impressionism*, Geneva and London, 1981

Jean S Boggs, *Portraits by Degas*, Berkeley, 1962

Jean S Boggs and A Maheux, *Degas Pastels*, London, 1992

Adelyn D Breeskin, *Mary Cassatt: A Catalogue Raisonné*, Washington, 1970

Richard R Brettell, *Pissarro and Pontoise*, New Haven and London, 1990

Judith Bumpus, *Impressionist Gardens*, London 1990

Kermit S Champa, *Studies in Early Impressionism*, New Haven and London, 1973

T J Clark, *The Painting of Modern Life: Paris in the Art of Manet and his Followers*, New York, 1985

Bernard Denvir, ed., *The Impressionists at First Hand*, London, 1987

Bernard Denvir, *Impressionist: The Painters and the Paintings*, London, 1991

Bernard Dunstan, *Painting Methods of the Impressionists*, London, 1976

Andrew Forge and Robert Gordon, *Monet*, New York, 1983

Andrew Forge and Robert Gordon, *Degas*, London, 1988

Tamar Garb, *Women Impressionists*, Oxford, 1986

Anne Coffin Hanson, *Manet and the Modern Tradition*, New Haven and London, 1977

Robert L Herbert, *Impressionism: Art, Leisure and Parisian Society*, New Haven and London, 1988

John House, *Monet: Nature into Art*, New Haven and London, 1986

Joel Isaacson, *Claude Monet: Observation and Reflection*, Oxford and New York, 1978

Horst Keller, *The Art of the Impressionists*, Oxford, 1980

Christopher Lloyd and Richard Thomson, *Impressionist Drawings from British public and private collections*, Oxford, 1986

Roy McMullen, *Degas: His Life, Times and Work*, Boston, 1984

Nancy Mowll Mathews, *Mary Cassatt*, New York, 1987

Charles S Moffett, ed., *The New Painting: Impressionism, 1874-1886*, Oxford, 1986

Howard Pickersgill, *The Impressionists*, London, 1979

Griselda Pollock, *Mary Cassatt*, New York, 1980

Theodore Reff, *Degas: The Artist's Mind*, New York, 1976

Theodore Reff, *Manet and Modern Paris*, Washington, DC, 1982

John Rewald, *The History of Impressionism*, New York, 1946, 4/1980

John Rewald, *Studies in Impressionism*, London, 1985

Scott Reyburn, *The Art of the Impressionists*, London, 1988

Keith Roberts, *Painters of Light: The World of Impressionism*, Oxford, 1978

Richard Shone, *Sisley*, London, 1992

Virginia Spate, *The Colour of Time: Claude Monet*, London, 1992

Richard Thomson, *Camille Pissarro*, New York, 1990

Paul Hayes Tucker, *Monet at Argenteuil*, New Haven and London, 1982

Paul Hayes Tucker, *Monet in the 90s*, New Haven and London, 1989

Kirk Varnedoe, *Gustave Caillebotte*, New Haven and London, 1987

Nicholas Wadley, *Impressionist and Post-Impressionist Drawing*, London, 1992

Barbara Ehrlich White, ed., *Impressionism in Perspective*, Englewood Cliffs, 1978

Barbara Ehrlich White, *Renoir: His Life, Art and Letters*, New York, 1984

Michael Wilson, *The Impressionists*, London, 1993

Pierre Wittmer, *Caillebotte and his Garden at Yerres*, New York, 1991

Sara R Witzling, *Mary Cassatt: A Private World*, New York, 1991

The Phaidon Colour Library series includes the following titles on Impressionists:

Catherine Dean, *Cézanne*, London, 1991

John House, *Monet*, London, 1992

Christopher Lloyd, *Pissarro*, London, 1992

John Richardson, *Manet*, London 1992

Keith Roberts, *Degas*, London, 1992

Richard Shone, *Sisley*, London, 1994

EXHIBITION CATALOGUES

Hommage à Claude Monet, Paris, Grand Palais, 1980

Pissarro, 1830-1903, London, Hayward Gallery and elsewhere, 1980-81

Manet, 1832-1883, New York, Metropolitan Museum and elsewhere, 1983

Mary Cassatt and Philadelphia, Philadelphia, Philadelphia Museum of Art, 1985

Renoir, London, Hayward Gallery and elsewhere, 1985

The New Painting: Impressionism, 1874-1886, Washington, DC, National Gallery of Art and elsewhere, 1986

The Private Degas, London, Hayward Gallery, 1987

Berthe Morisot, Impressionist, Washington, DC, National Gallery of Art, 1987-8

Degas, New York, Metropolitan Museum of Art and elsewhere, 1988-9

Sisley, London, Royal Academy and elsewhere, 1992-3

Frédéric Bazille: Prophet of Impressionism, New York, Brooklyn Museum and elsewhere, 1992-3

The Impressionist and the City: Pissarro's Series Paintings, London, Royal Academy and elsewhere, 1992-3

List of illustrations

Colour Plates

1. Edouard Manet
 Music in the Tuileries
 1862. Oil on canvas. London, National Gallery

2. Edouard Manet
 Le Déjeuner sur l'Herbe
 1863. Oil on canvas. Paris, Musée d'Orsay

3. Edouard Manet
 Olympia
 1863. Oil on canvas. Paris, Musée d'Orsay

4. Claude Monet
 Ladies in the Garden
 1866-7. Oil on canvas. Paris, Musée d'Orsay

5. Claude Monet
 Garden of the Princess
 1867. Oil on canvas. Oberlin, Allen Memorial Art
 Museum

6. Pierre Auguste Renoir
 The Pont des Arts
 1867. Oil on canvas. Los Angeles, Norton Simon
 Foundation

7. Frédéric Bazille
 The Family Gathering
 1867-8. Oil on canvas. Paris, Musée d'Orsay

8. Edouard Manet
 Portrait of Emile Zola
 1868. Oil on canvas. Paris, Musée d'Orsay

9. Edouard Manet
 The Balcony
 1868-9. Oil on canvas. Paris, Musée d'Orsay

10. Pierre Auguste Renoir
 La Grenouillère
 1869. Oil on canvas. Stockholm, National Museum

11. Henri Fantin-Latour
 A Studio in the Batignolles
 1870. Oil on canvas. Paris, Musée d'Orsay

12. Edgar Degas
 The Orchestra of the Opera
 c.1870. Oil on canvas. Paris, Musée d'Orsay

13. Claude Monet
 The Thames below Westminster
 1871. Oil on canvas. London, National Gallery

14. Camille Pissarro
 Lordship Lane Station, Dulwich
 1871. Oil on canvas. London, Courtauld Institute
 Galleries

15. Berthe Morisot
 The Cradle
 1872. Oil on canvas. Paris, Musée d'Orsay

16. Camille Pissarro
 Entrance to the Village of Voisins
 1872. Oil on canvas. Paris, Musée d'Orsay

17. Claude Monet
 Impression: Sunrise
 1873. Oil on canvas. Paris, Musée Marmottan

18. Paul Cézanne
 Dr Gachet's House at Auvers
 c.1873. Oil on canvas. Paris, Musée d'Orsay

19. Eugène Boudin
 Beach at Trouville
 1873. Oil on panel. London, National Gallery

20. Edgar Degas
 The Ballet Rehearsal
 1873-4. Oil on canvas. Paris, Musée d'Orsay

21. Edgar Degas
 The Dance Class
 1873-5/6. Oil on canvas. Paris, Musée d'Orsay

22. Claude Monet
 Bridge at Argenteuil
 1874. Oil on canvas. Washington, DC, National
 Gallery of Art

23. Edouard Manet
 Monet Painting in his Floating Studio
 1874. Oil on canvas. Munich, Neue Pinakothek

45. Claude Monet
Rouen Cathedral, Façade (Morning Effect)
1892-4. Oil on canvas. Essen, Folkwang Museum

46. Camille Pissarro
The Pont Boïeldieu, Rouen
1896. Oil on canvas. Pittsburgh, Carnegie Museum

47. Camille Pissarro
Boulevard des Italiens, Paris: Morning
Sunlight
1897. Oil on canvas. Washington, DC, National
Gallery of Art

48. Camille Pissarro
Place du Théâtre Français, Paris: Rain
Effect
1898. Oil on canvas. Minneapolis, Minneapolis
Institute of Art

Text Illustrations

1. Courbet
Burial at Ornans
1850. Oil on canvas. Paris, Musée d'Orsay

2. Monet painting at Giverny
c.1915.

3. Jongkind
Sainte Adresse
1862. Oil on canvas. Private collection

4. Renoir
Self-portrait
1876. Oil on canvas. Cambridge, MA, Fogg Art
Museum

5. Photograph of Manet by Nadar
c.1865

6. Pissarro
Self-portrait
1903. Oil on canvas. London, Tate Gallery

7. Monet
Poppy Field at Argenteuil
1873. Oil on canvas. Paris, Musée d'Orsay

8. Pissarro
The Red Roofs (Côte St Denis at
Pontoise)
1877. Oil on canvas. Paris, Musée d'Orsay

9. Pissarro
Kitchen Garden and Trees in Blossom
1877. Oil on canvas. Paris, Musée d'Orsay

10. Monet
Nymphéas
c.1916-26. Oil on canvas. Paris, Orangerie, right
panel, Room II

Comparative Figures

11. Titian or Giorgione
 Pastoral Concert
 c.1510. Paris, Musée du Louvre

12. Cabanel
 Birth of Venus
 1863. Oil on canvas. Paris, Musée d'Orsay

13. Caricature of Manet's Olympia
 1865. Drawing in *Le Journal Amusant*. Paris, Viollet
 Collection

14. Monet
 Saint-Germain l'Auxerrois
 1867. Oil on canvas. Berlin, Staatliche Museum
 National Galerie

15. Bazille
 Self-portrait
 1865. Oil on canvas. Chicago, Art Institute of
 Chicago

16. Goya
 Majas on a Balcony
 c.1811. New York, Metropolitan Museum of Art

17. Monet
 La Grenouillère
 1869. Oil on canvas. New York, Metropolitan
 Museum of Art

18. Monet
 Towers of Westminster
 1903. Oil on canvas. Le Havre, Musée des Beaux-
 Arts

19. Monet
 Green Park
 1871. Oil on canvas. Philadelphia, Philadelphia
 Museum of Art

20. Pissarro
 Crystal Palace
 1871. Oil on canvas. Chicago, Art Institute of
 Chicago

21. Turner
 Rain, Steam and Speed: The Great
 Western Railway
 1844. Oil on canvas. London, National Gallery

22. Cézanne
 Moderna Olympia
 1872-3. Oil on canvas. Paris, Musée d'Orsay

23. Corot
 Church of Marissel
 1866. Oil on canvas. Paris, Musée d'Orsay

24. Cézanne
 Temptation of St Anthony
 1869. Oil on canvas. Zurich, Fondation E G Bührle
 Collection

25. Cézanne
 Mont Sainte-Victoire
 1885-7. Oil on canvas. London, Courtauld Institute
 Galleries

26. Boudin
 Beach at Trouville
 1865. Oil on canvas. Private collection

27. Manet
 The Monet Family in their Garden
 1874. Oil on canvas. New York, Metropolitan
 Museum of Art

28. Sisley
 Sentier de la Mi-côte, Louveciennes
 1873. Oil on canvas. Paris, Musée d'Orsay

29. Monet
 Gare Saint-Lazare: Signal
 1877. Oil on canvas. Private collection

30. Manet
 Boating
 1874. Oil on canvas. New York, Metropolitan
 Museum of Art

31. Manet
 The Plum
 c.1878. Oil on canvas. Washington, DC, National
 Gallery of Art

32. Cassatt
A Woman in Black at the Opera
c.1879. Oil on canvas. Boston, Museum of Fine Arts

33. Degas
Woman in a Tub
1886. Bronze. Edinburgh, National Gallery of
Scotland

34. Monet
Grainstacks at Sunset: Frosty Weather
1890-91. Oil on canvas. Private collection

35. Monet
Poplars: Wind Effect
1891. Oil on canvas. Private collection

1

EDOUARD MANET (1832-83)
Music in the Tuileries

1862. Oil on canvas, 76 x 118 cm. London, National Gallery

This is a seminal work both in Manet's oeuvre and in the development of Impressionism, firstly because it deals with contemporary subject-matter, in particular that of bourgeois recreation, and secondly because of its very abbreviated manner of execution. The Tuileries Gardens in Paris was the location for various events at which fashionable members of society gathered (Manet was himself of an haute bourgeois family). Music concerts essentially provided a pretext for socializing and thus most of the figures are here seen chatting. Though many are only loosely characterized, several of the figures can be identified. Manet himself stands on the furthest left and next to him is the painter Albert de Balleroy (1828-72), with whom he shared a studio. The bearded man seated near Balleroy and looking out is the critic Zacharie Astruc. Other figures include Eugène Manet, Manet's brother, in profile and bowing, the composer Jacques Offenbach to Eugène's right wearing pince-nez and with his back to a tree. The group gathered by a tree to Astruc's left includes, nearest to Astruc, the poet and critic Charles Baudelaire, who had urged painters to take up themes from 'modern life'.

As with others of his works, Manet drew on various sources for the composition. These include the numerous popular prints of the period, showing similar scenes at the Tuileries, and also a painting attributed to Velázquez, of which Manet had made an engraving. The Spanish work shows a gathering of elegantly dressed men, including Velázquez himself and Murillo. Manet here depicted himself and Balleroy in similar positions to Velázquez and Murillo respectively, so implying that he is a worthy successor to Velázquez. Though based on sketches made on the spot, Manet painted the work itself in his studio. The daring style of execution is evident not only in the cursory treatment of the figures but in the broad, flat band of trees along the top. Whereas the women and children add to the colour and variety of the scene, the men, all dressed in black and mostly standing, echo the tree trunks. Even the new, wrought-iron chairs, with their arabesque design, are made an integral feature of the composition. Exhibited at the Galerie Martinet in 1863, the painting caused a scandal, and was criticized both for its technique and colouring. Baudelaire himself seemed little impressed by the work, even though it ostensibly fulfilled his own prescriptions to artists.

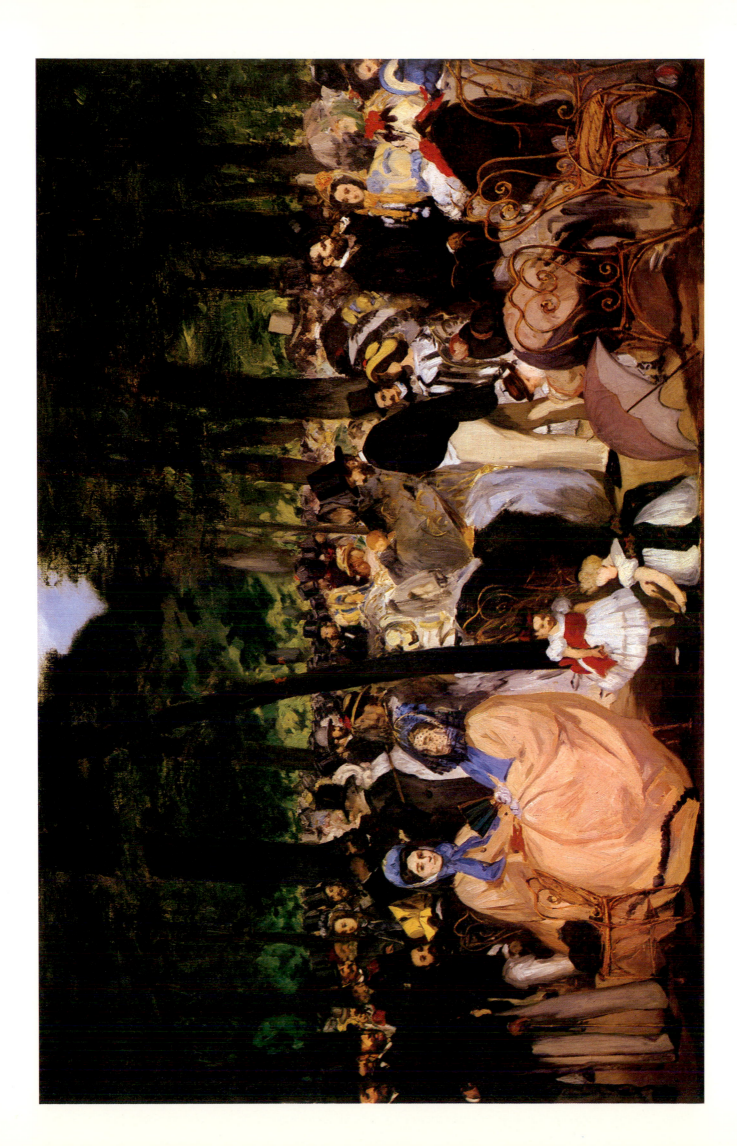

EDOUARD MANET (1832-83)
Le Déjeuner sur l'Herbe

1863. Oil on canvas, 208 x 264 cm. Paris, Musée d'Orsay

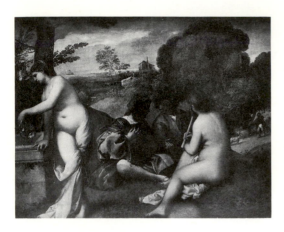

Fig. 11
Titian or Giorgione
Pastoral Concert
c.1510. Oil on canvas,
109 x 137 cm. Paris,
Musée du Louvre

This work was shown at the notorious Salon des Refusés in 1863, where it caused the greatest scandal of any canvas there. It has since come to symbolize one of the turning points in modern art. What so angered contemporary critics was partly its technique, but more especially its apparently flagrant and immoral subject-matter. Visitors to the exhibition immediately saw it as showing two young men — their dress identifying them as students — enjoying the company (and more) of two young women, perhaps prostitutes. The female nude was identifiable as Victorine Meurent, an artist's model, who was depicted and named in another of Manet's works at the same exhibition. As artist's models were generally thought promiscuous, this knowledge added to the impact, while her direct gaze invited an unwanted participation in the scene. The man on the right may be modelled on one or both of Manet's brothers, Eugène and Gustave, while the other is the Dutch sculptor Ferdinand Leenhoff, whose sister Manet later married. The identity of the scantily clad female in the background is not known, though she may also have been modelled on Victorine.

Nudes were acceptable in art so long as they were not seen to represent 'real' people; rather, they had to be allegorical and anonymous, as in the works of contemporary academic painters. At the exhibition Manet entitled this work *Bathing* (he changed the title four years later), which suggested to the public that it did indeed depict a contemporary, 'real' scene. The still-life of the picnic enhances the aura of sensual indulgence: among its contents are a silver flask of wine, rather than an ordinary bottle. The adept execution of this element demonstrated to contemporaries that it was not through ignorance or incompetence that Manet had painted the work as it was, rather it was an example of wilful deviation. The composition is such that the landscape appears as if it were a stage set, with which the figures are not fully integrated. This may be a deliberate feature of the work or possibly a failing — Manet had encountered similar problems with a group of earlier paintings of figures in landscapes.

The painting draws on both Titian's *Pastoral Concert* (Fig. 11) in the Louvre (also attributed to Giorgione) and, more directly, on a print by Marcantonio Raimondi after Raphael's *Judgement of Paris*. This print was well-known in artists' studios, and Manet copied the poses of a nymph and two sea gods for his three central figures. Comments on the painting were numerous, one critic calling it an 'uncouth riddle', while another claimed that Manet's taste was 'corrupted by an infatuation with the bizarre'. Manet must certainly have painted the work with at least the intention of attacking pictorial conventions if not public morals also. The painting's allusion to great art of the past may indicate that Manet saw himself as a successor to the Old Masters, though it could alternatively be an ironic means of subversion. In spirit and subject-matter Manet here also aligns himself with Courbet, whose uncompromisingly realistic works had likewise scandalized the public.

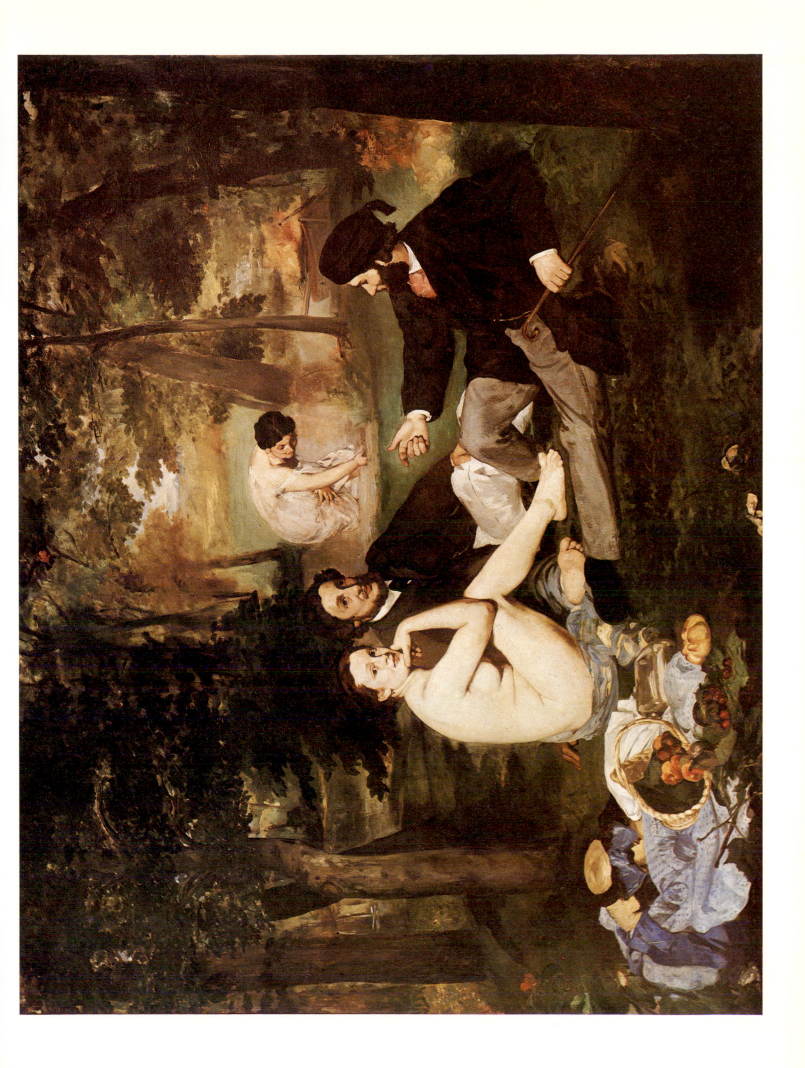

EDOUARD MANET (1832-83)
Olympia

1863. Oil on canvas, 131 x 190 cm. Paris, Musée d'Orsay

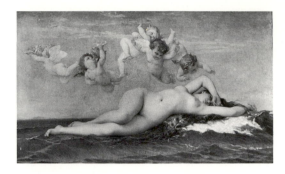

Fig. 12
Cabanel
Birth of Venus
1863. Oil on canvas,
130 x 225 cm, Musée
d'Orsay

Fig. 13
Caricature of Manet's
Olympia
1865. Drawing in
Le Journal Amusant. Paris,
Viollet Collection

Though painted in 1863 Manet did not exhibit this work until 1865, when it was accepted for the Salon: he probably wanted to allow the storm caused by *Le Déjeuner sur l'Herbe* to subside. The reaction to this work was, however, even more violent: as before the subject-matter was seen as vulgar and immoral, an insult to good taste. The nude was once again modelled on Victorine Meurent, but in contrast to those by contemporary Salon painters or Old Masters, Manet made no attempt to idealize her or to present her as, say, a figure of Venus (as in the work of the same date by the successful academic painter, Alexandre Cabanel, Fig. 12). Instead he depicted her as he saw her, while casting her in the role of prostitute, shown receiving flowers from one of her clients, while awaiting the next. Her insistent and direct gaze implies that the viewer is a prospective visitor, though her expression is not one of invitation, rather of a cool indifference born of familiarity with her work. The few items she wears – bracelet, neck ribbon and a single shoe – serve to emphasize her nudity, while the presence of the black maidservant adds a note of exoticism that contemporaries would have associated with the harem scenes so beloved of Salon painters. At the foot of the bed, its yellow eyes staring outwards, is a black cat, whose significance is ambiguous: it probably symbolizes erotic pleasure as well as connoting evil and witchcraft. At the same Salon Manet also showed *Jesus Mocked by the Soldiers*, and this pairing of religious and aggressively secular subjects rendered *Olympia* even more inflammatory.

The pose of the nude is very similar to that of Titian's *Venus of Urbino* in the Uffizi (in which there is a sleeping dog at the feet of Venus). However, the provocative directness of the painting is closer to Goya's *Naked Maja*. Numerous other sources have been cited, including contemporary Salon paintings of odalisques or even pornographic photographs of the era. Manet is supposed to have taken the title from a mediocre poem written by Astruc in 1864, which may have had a subversive appeal because of its mythological resonance. He quoted the first five lines of it on the exhibition label, further clarifying the meaning of the work. While much of the criticism focused on the subject, there were also attacks on its execution: on the use of a harsh outline for the figure and on the 'ugly' colour scheme, particularly in the flesh tones. Furthermore, Manet seemed to make no distinction between the various elements: the face was treated no differently from the flowers or fabrics. Since its execution, perhaps even more so than *Le Déjeuner sur l'Herbe*, this work has come to occupy a unique place in modern art and has frequently been both reworked (Fig. 22) and satirized (Fig.13).

CLAUDE MONET (1840-1926)
Ladies in the Garden

1866-7. Oil on canvas, 255 x 205 cm. Paris, Musée d'Orsay

This work was painted at Ville-d'Avray near Paris, to where the artist had fled in order to escape his creditors. Begun in the summer of 1866, it was finished during the winter. At least three of the figures were modelled by Camille Doncieux, then Monet's mistress and later his wife. Though finished in the studio, much of the painting was done outside and, because of the size of the canvas, Monet had to dig a trench in the garden into which the picture could be lowered so as to enable him to paint the upper parts. He would also stop work as soon as the light faded, and this determined adherence to open air painting was laughed at by both Courbet, who was an occasional visitor during its execution, and Manet.

Important in Monet's development, this picture shows how the artist's palette was brightening and reveals his careful attention to light effects. The woman in the foreground sits in a blue-toned shadow, the result of light from the sky reflecting up from her white dress, while in the figure on the furthest left flesh tones show through her dress. Aside from its progressive technique, there are possibly other reasons why the work was refused for the 1867 Salon. A painting of this scale was expected to transmit some elevating message through ennobling subject-matter, yet the viewer is offered nothing of this here: there is no obvious narrative or other link between the elements of the picture nor is there even a focus of attention. Instead we are merely presented with an everyday, outdoor scene (though, like most of Monet's works, it is carefully organized).

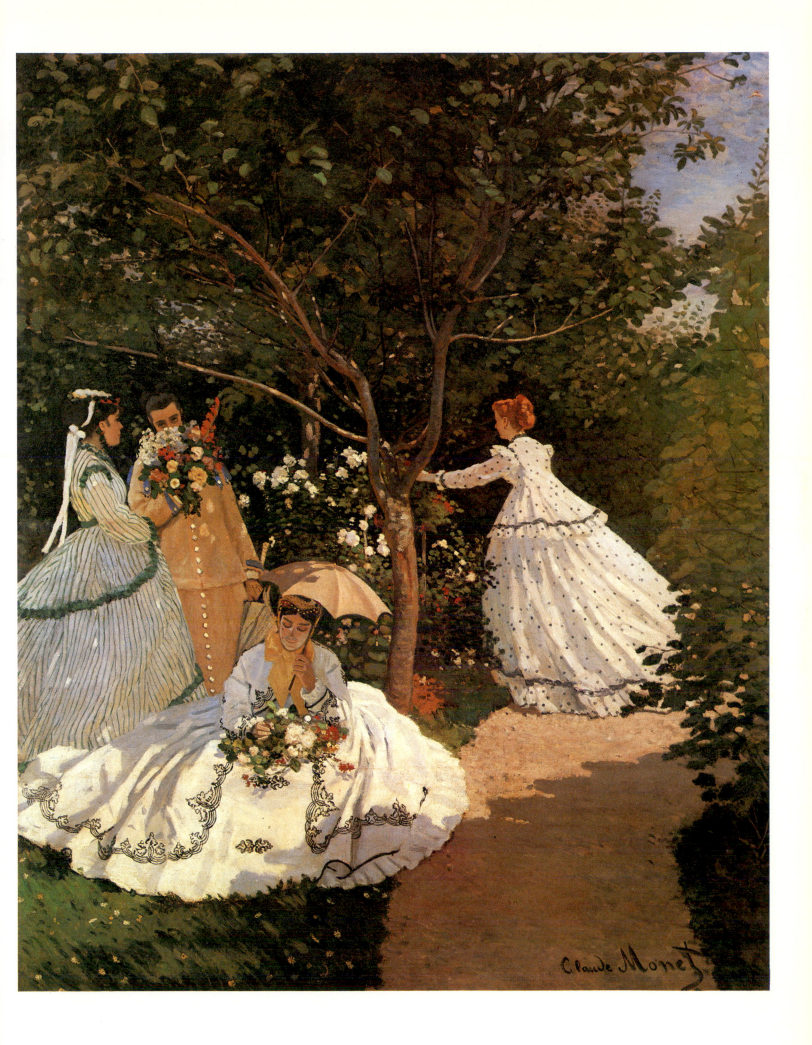

5

CLAUDE MONET (1840-1926)
Garden of the Princess

1867. Oil on canvas, 91 x 62 cm. Oberlin, Allen Memorial Art Museum

This is one of three cityscapes Monet painted in 1867 together with Renoir (see Plate 6), and these constitute his first important scenes of urban life (see also Fig. 14). Monet worked on the other side of the river to Renoir, and all three pictures were painted from the second floor of the Louvre. This one shows an area recently redeveloped by Baron Georges Haussmann, who had been appointed by Napoleon III to rebuild much of central Paris. The Garden of the Princess is in the foreground and adjoins the Quai du Louvre, the exclusive subject of one of the other three pictures. In the distance, at the centre of the composition, is the dome of the Panthéon, while scarcely visible is the Seine, which runs in between the two groups of trees. In contrast to Renoir's picture of the Pont des Arts, which was taken from a ground-level perspective, we here look down onto the scene below from a distance. As a consequence, and in keeping with Monet's general approach, the figures are less individualized than in Renoir's painting. The Quai du Louvre, bustling with life and filled with carriages and pedestrians, is visually distanced by the large expanse of the Garden of the Princess, which is rendered as an essentially flat area of green, devoid of activity and surrounded by a perimeter fence. By the side of the river flies the French flag (which marks the site of a government dock), its red third immediately catching the eye. Together with the Panthéon, where several of France's great citizens are buried, the two most prominent elements of the work are thus symbols of the State. These national references are reinforced by the fact that the work was executed in a year when one of the great Expositions Universelles was being held.

Fig. 14
Monet
Saint-Germain
l'Auxerrois
1867. Oil on canvas,
79 x 98 cm. Berlin,
Staatliche Museum
National Galerie

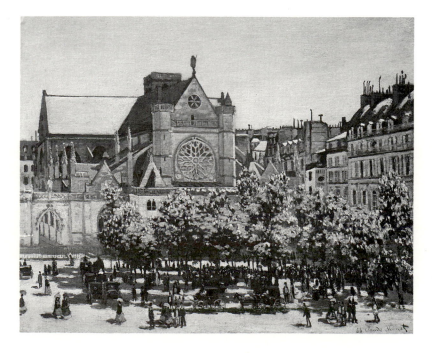

6 PIERRE AUGUSTE RENOIR (1841-1919)
The Pont des Arts

1867. Oil on canvas, 62 x 103 cm. Los Angeles, Norton Simon Foundation

The wide, panoramic format of this work is unusual in Renoir's oeuvre. This is one of the first of his scenes of contemporary urban life, of which he executed others during that year in the company of Monet (see Plate 5). The work was painted in the year of the Exposition Universelle, which brought thousands of visitors to Paris to see the pavilions set out on the Champs de Mars and which the government hoped would demonstrate the industrial and cultural pre-eminence of France. Renoir's picture shows the dome of the Institut de France on the right and the Pont des Arts arching across the Seine on the left. The whole scene is one of lightness and space, made possible by Renoir's choice of site: the Quai Malaquais, which dominates the work, had recently been widened by Haussmann. In the immediate foreground can be seen the shadows of the pedestrians on the Pont du Carrousel overhead, while in the middle we see a river cruiser disgorging its passengers onto the quay. Other figures are scattered along the bridge itself. The picture incorporates a mixture of social types: a working class woman with her children on the right, imperial guardsmen (in their bright red trousers) at the top of the steps leading to the bridge, and fashionably dressed residents and tourists scattered elsewhere. It is precisely this sort of bright, airy image, alive with activity and rendered with an objective eye, that was so characteristic of Impressionism, marking it off from earlier artistic schools.

FRÉDÉRIC BAZILLE (1840-70)
The Family Gathering

1867-8. Oil on canvas, 152 x 227 cm. Paris, Musée d'Orsay

Fig. 15
Bazille
Self-portrait
1865. Oil on canvas,
135 x 80 cm. Chicago,
Art Institute of Chicago

Though begun in the summer of 1867, three years before Bazille's premature death in the Franco-Prussian War, this painting took almost eight months to complete and is now widely considered to be his masterpiece. It depicts the Bazille and des Hours-Farel families at the Bazille estate at Méric near Montpellier, all posed under a chestnut tree with a broad landscape in the background. The artist himself is seen on the far left, next to his uncle, Eugène des Hours-Farel. Seated in the near foreground are his mother, Camille, and, father Gaston. On the right on the terrace is Bazille's brother Marc with his wife Suzanne and cousin Camille des Hours-Farel. The figures seem rather stiff and formal, a quality heightened by the direct stare of many of them, and the depiction of the artist and his uncle has an almost naïve air about it.

Though showing an outdoor scene and based on numerous preparatory sketches, Bazille finished the work in his studio in Paris. In contrast to the more fully developed form that Impressionism was to take after Bazille's death, this work seems, in both composition and brushwork, very deliberate and meticulous: as shown, for example, by the attention paid to each leaf of the chestnut tree and to the fabric of the sitters' clothes. Bazille had painted another outdoor family scene in 1866-7, which, while less formal in composition, was rather awkwardly painted and was refused at the Salon of 1867. The work shown here, much to Bazille's surprise, was accepted at the Salon of 1868 together with another, entitled *Flower Pots*. There it received favourable reviews from the critics Zola and Castagnary. Zola praised it both for its contemporary subject-matter and for the 'strong love of truth' he felt was apparent in it.

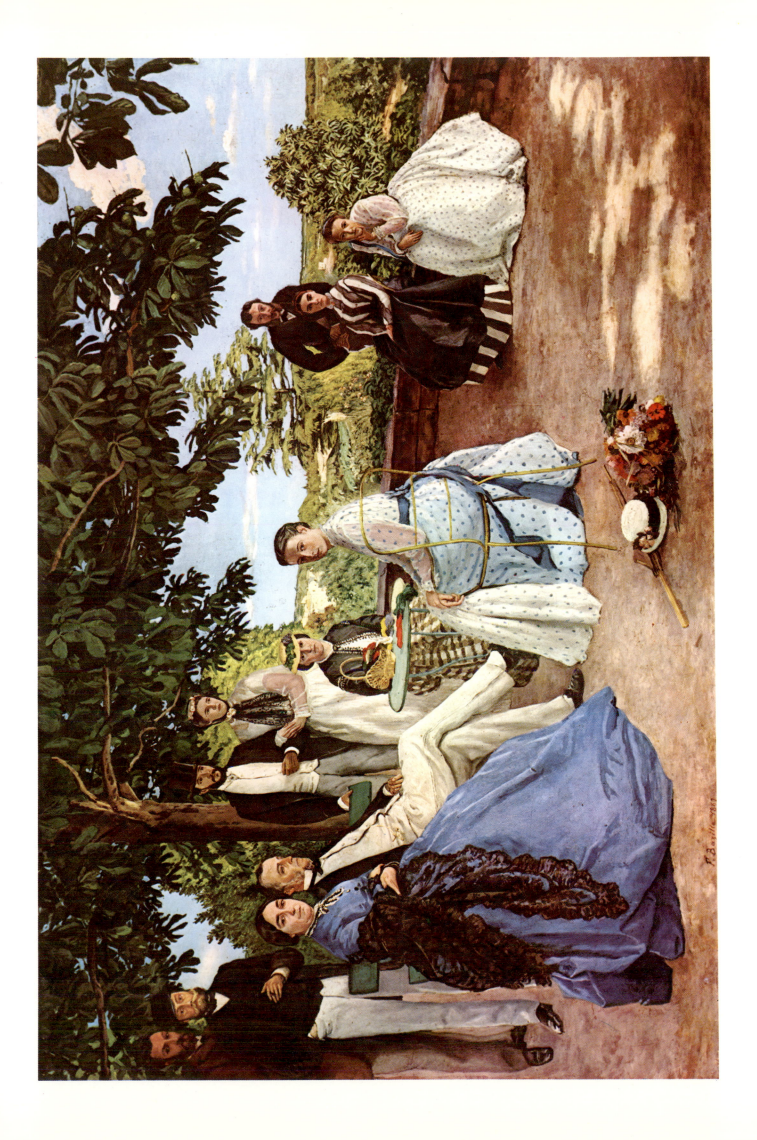

8 EDOUARD MANET (1832-83)
Portrait of Emile Zola

1868. Oil on canvas, 146 x 114 cm. Paris, Musée d'Orsay

Emile Zola (1840-1902) was a childhood friend of Cézanne, and it was probably the latter who introduced him to the Paris art world (Cézanne took him to the Salon of 1861). Zola, later more famous as a naturalist novelist, began his career as an art critic. He saw the Salon des Refusés in 1863, although his first writings on art did not appear until his review of the Salon in *L'Evénement* in 1866. Despite his friendship with Cézanne, Zola found his art incomprehensible and essentially a failure (he later called him 'an aborted genius'). He became, instead, one of the earliest and most outspoken of Manet's supporters. At the 1866 Salon he singled out a landscape by Pissarro for particular praise. Though Manet's works had been refused, in the same review he took the opportunity to claim that Manet's place was 'marked out for him in the Louvre'. The artist and the critic probably first met in 1866 and in 1867 Zola wrote a longer, more substantial defence of Manet. In gratitude for his support, Manet decided to paint Zola's portrait, for which the critic sat in February 1868.

While ostensibly a portrait of Zola, the work is in fact filled with details that refer more to the artist than to the sitter. The blue pamphlet on the desk is that which Zola wrote on Manet in 1867. Above the desk is a print or photo of Olympia in front of an engraving after Velázquez's *Los Borrachos* (*The Drunkards*), the latter reflecting Manet's interest in Spanish art. The Japanese print, showing a samurai, and the Japanese screen to the left are again indications of Manet's sources of inspiration. The nude in Olympia is slightly altered such that, rather than staring out at the viewer, she looks at Zola, so making him the focus. Zola's pose is formal and the composition essentially traditional. His expression is impassive and the detached treatment evident in the work, as well as being typical of Manet's approach, reflects the fact that Zola was only a recent acquaintance of the artist. Further, though thankful for his support, Manet felt somewhat distant from the writer's artistic aims. In the same way that Manet here sees Zola in his own terms, Zola saw Manet's work within the context of his own aesthetic, which centred on the notion that a work of art should be 'nature seen through a powerful temperament'.

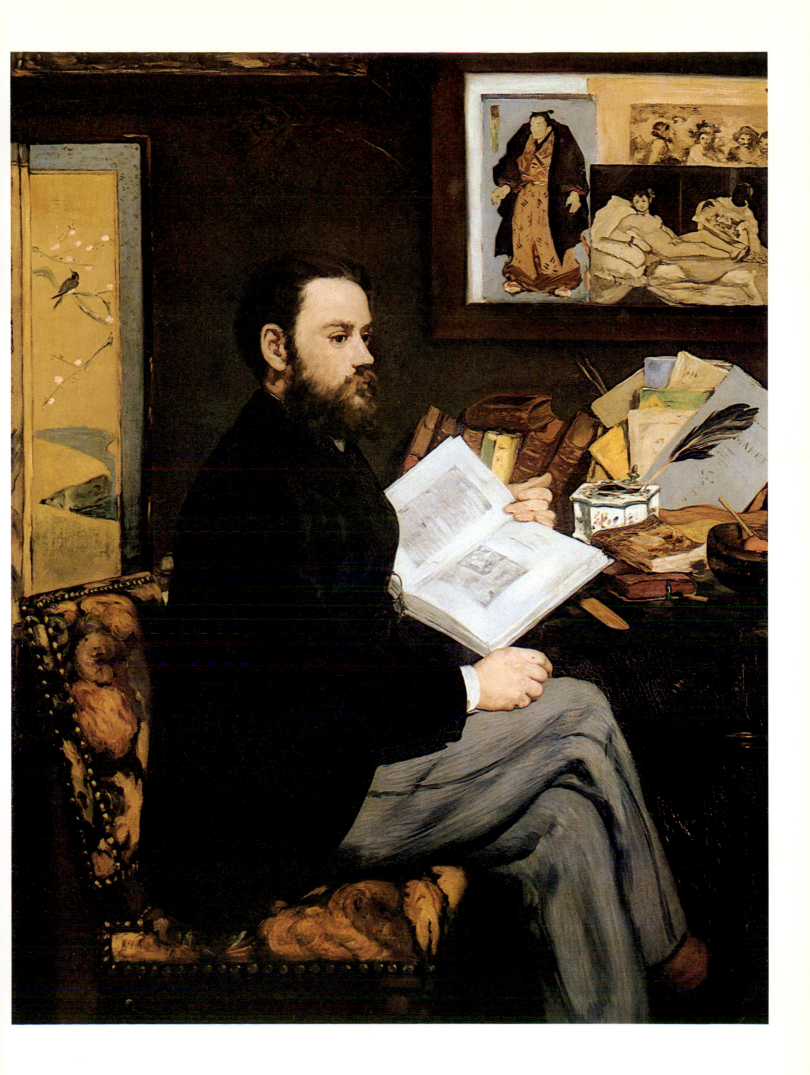

EDOUARD MANET (1832-83)
The Balcony

1868-9. Oil on canvas, 169 x 125 cm. Paris, Musée d'Orsay

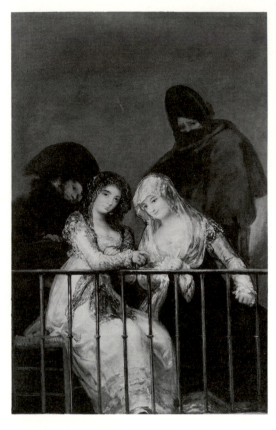

Fig. 16
Goya
Majas on a Balcony
c.1811. Oil on canvas,
195 x 126 cm. New York,
Metropolitan Museum
of Art

The three figures in this work are, from left to right, Berthe Morisot, Antoine Guillemet (a landscape painter and friend of the Impressionists), and Fanny Claus (a concert violinist). In the background can be seen a boy bearing a pitcher, presumably intended for those on the balcony. Manet claimed that the idea for the work came to him after seeing a group on a balcony in Boulogne; another inspiration is clearly Goya's *Majas on a Balcony* (Fig. 16), though there are several other treatments of this theme also. While Manet pays homage to the Spanish artist, he also emphasized their differences. In contrast to the animation and warm, harmonious colouring of Goya's painting, Manet used bright, contrasting colours, and his figures seem oddly posed and distracted. Their formality is highlighted by the lack of activity: each figure gazes in a different direction and there seems to be no interaction. The man's hand gestures and expression suggest that he is totally absorbed in his thoughts, while Fanny looks blankly out at the viewer without seeming aware of anything before her. This disconnectedness, which now gives the work a poetic, mysterious air, was disliked by contemporary critics when it was exhibited at the Salon of 1869. They expected a work of this nature to combine the figures into some comprehensible image through narrative and other links. While the identity of the sitters is known, this knowledge explains little, and one could not really call the work a portrait. The sitters themselves were not wholly pleased: Morisot felt she appeared strange, and Guillement claimed that Claus looked 'terrible'. The bright green of the balcony and shutters, coupled with the startling blue of Guillemet's cravat, make the colouring of the work most striking, enhancing its air of artificiality. The addition of the dog at Morisot's feet enlivens an otherwise marginal part of the composition, a pictorial device used by Manet elsewhere (e.g. the cat in *Olympia*).

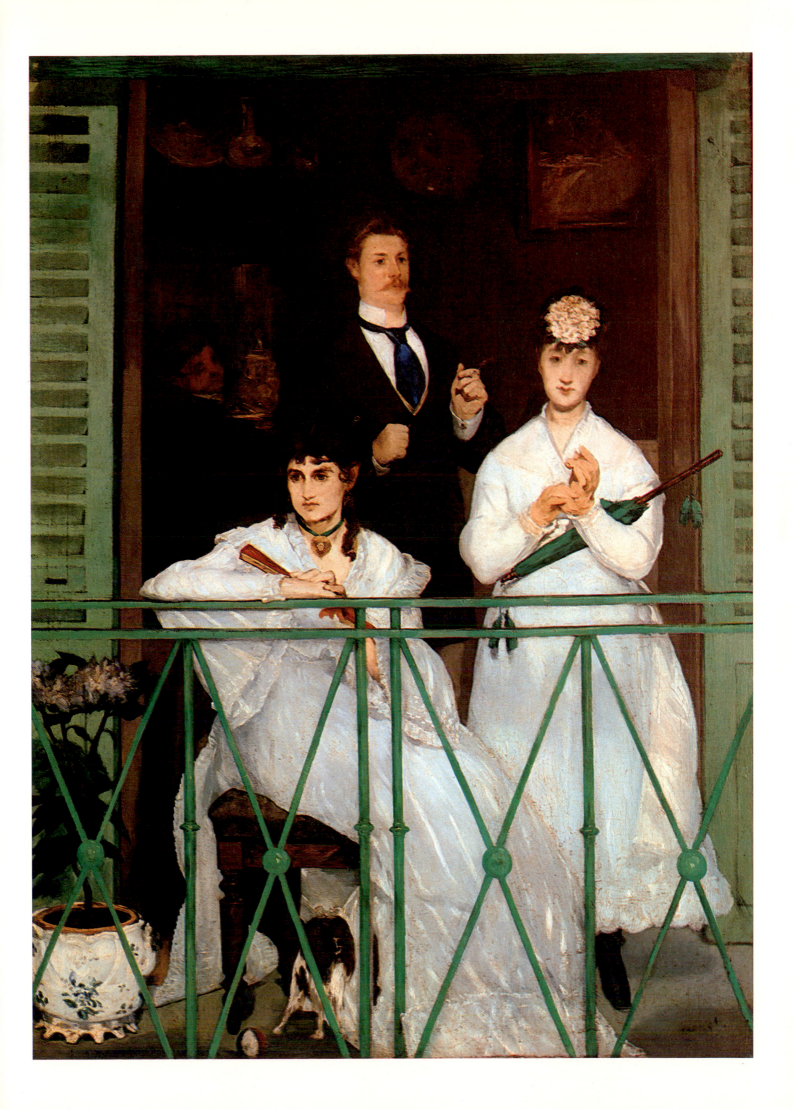

PIERRE AUGUSTE RENOIR (1841-1919)
La Grenouillère

1869. Oil on canvas, 66 x 86 cm. Stockholm, National Museum

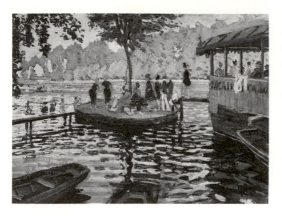

Fig. 17
Monet
La Grenouillère
1869. Oil on canvas,
75 x 100 cm. New York,
Metropolitan Museum
of Art

La Grenouillère (literally the 'Frog Pond') was a café and bathing establishment on the Ile de Croissy on the Seine, close to Bougival. It became extremely fashionable and popular in the 1860s, and numerous articles were devoted to the site in the press. The visitors ranged from artists and writers to aristocrats, and its prestige was finally confirmed by the visit of Napoleon III and Empress Eugénie in July 1869. Renoir painted this work in the company of Monet, who painted a scene very similar to this (Fig. 17). In the same year they also painted another pair focusing on a different view of the location. These works of both artists mark an important stage in their progression towards the spontaneous Impressionist technique that characterize those of the 1870s.

Comparison with Monet's painting of this view reveals the differing interests and approaches of the artists. Renoir took a closer viewpoint dominated by the round islet (the 'Camembert' or 'Flowerpot') as this allowed him to concentrate more on the human aspects of the scene. His figures are both more numerous and individualized, and in addition to the figures on the islet, there are rowers and sailing boats in the background. By contrast, Monet shows more of the landscape, typically his prime interest, and merely suggests the form and dress of the few figures in simple, broad strokes. The highlighting in black of the structural features – footbridges, islet and café building – coupled with the parallel, black strokes of the water ripples, gives his work a much stronger composition. The palette of Renoir's painting is much lighter and more restricted (essentially to blues and greens) and his brushstrokes are much softer in touch. The feathery trees in the background merge almost indistinctly into the water below, giving the whole work a shallow pictorial space and serving to emphasize the figures.

This painting, together with its companion, looks forward to Renoir's complex outdoor scenes of the 1870s and early 1880s, such as *Dance at the Moulin de la Galette*, and displays a new facility in dealing with themes from modern life: before this he had largely focussed on a few monumental figures. The economy of the brushwork is an additional development, enabling him to capture the dress and pose of the figures with only a handful of carefully worked strokes and to indicate the water surface with broad, distinct marks. More so than in previous works, this image truly seems to capture the life and appearance of a fleeting moment.

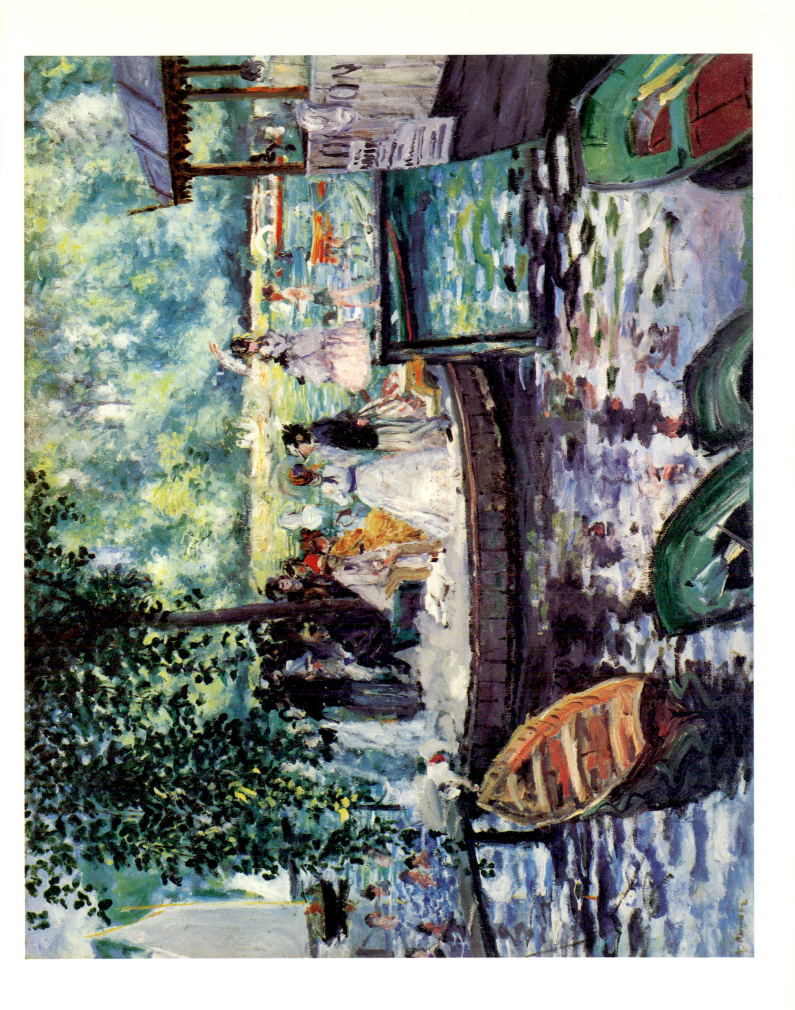

11 HENRI FANTIN-LATOUR (1836-1904)
A Studio in the Batignolles

1870. Oil on canvas, 204 x 273 cm. Paris, Musée d'Orsay

Throughout the 1860s and until his death Manet lived in the Batignolles area of Paris, situated around the Boulevard des Batignolles north of the Gare Saint-Lazare. He is shown here surrounded by a group of his admirers, reflecting his position as the leader of a new generation of painters. Seated next to him is the critic Zacharie Astruc, whose portrait Manet is shown painting. The other figures, standing from left to right are: Otto Scholderer (a painter), Renoir, Emile Zola (see Plate 8), Edmond Maître (a civil servant who devoted much of his time to music), Bazille and Monet. During the 1860s the members of this group used to gather at the Café Guerbois in the Grande Rue des Batignolles (now called the Avenue Clichy), where Manet would 'hold court'.

To some extent this work alludes to Velázquez's famous *Las Meninas* in the Prado (though there are numerous other precedents for this type of composition). This both indicates Manet's admiration for the Spanish painter as well as acting as a homage to Manet himself by casting him in the same role as Velázquez (see also Plate 1). When exhibited at the Salon of 1870 few took note of the subject-matter, though those that did disliked the notion of giving such prominence to Manet. The caricaturist Bertall published a parody with the caption: 'Jesus painting in the midst of his disciples, or the divine school of Manet, religious painting by Fantin-Latour'. Though a friend of the Impressionists, Fantin-Latour remained apart from the movement aesthetically and declined an invitation to participate in the First Impressionist Exhibition of 1874.

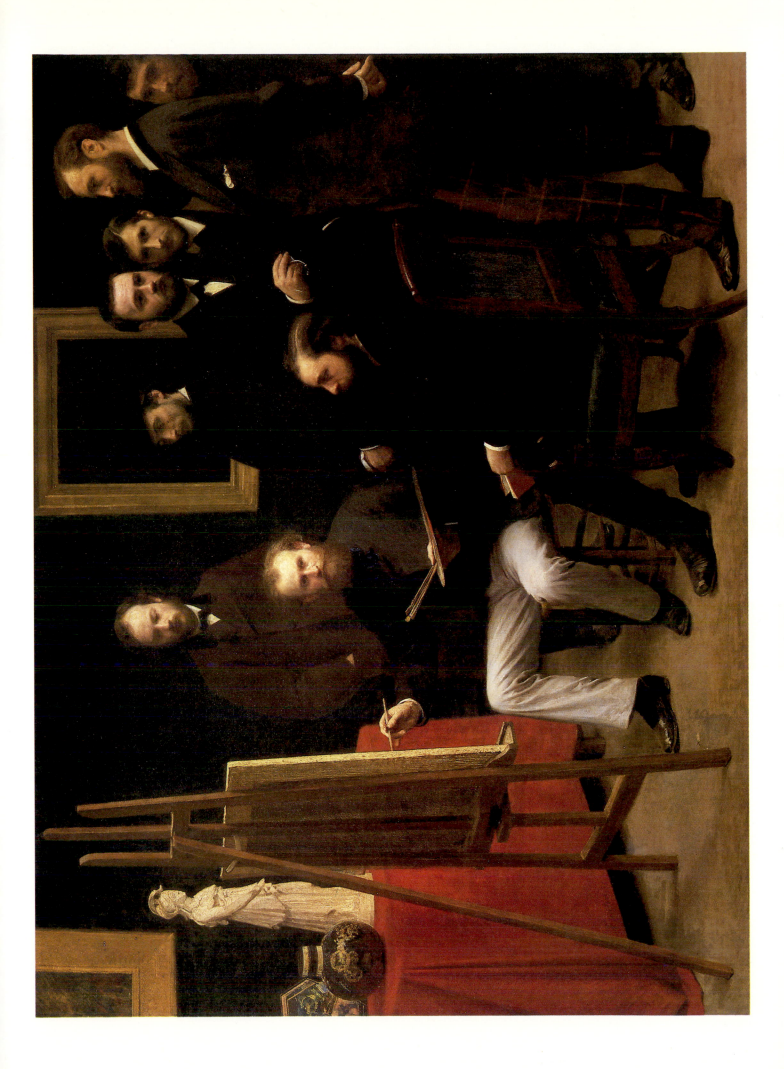

EDGAR DEGAS (1834-1917)
The Orchestra of the Opera

c.1870. Oil on canvas, 56 x 46 cm. Paris, Musée d'Orsay

This is the first of Degas' depictions of the Opéra and has often been seen as marking the final break with his history paintings of the early 1860s. It is essentially a portrait of his bassoonist friend Désiré Dihau, who is seated in the centre, in a position that would more normally have been occupied by one of the first violins. Other figures can also be identified: the cellist Louis-Marie Pilet on the left and the double-bass player Gouffé (probably Achille Henri Victor Gouffé) with his back to the viewer. Apart from musicians Degas also included painters and other friends not associated with the orchestra, while in the box on the far left is the almost caricatural figure of the composer Emmanuel Chabrier, a friend of Manet among others. The orchestra is strongly framed by the sharply picked out edge of the stage and the foreground side of the orchestra pit. Other elements, such as the instruments, white shirt fronts and the chair back, add to the compositional order. The dark, dominantly black tone of the foreground figures contrasts sharply with the stage-lit dancers in the background. However, so as not to distract from the orchestra, the dancers are shown cut off at the shoulder. In comparison with the careful finished treatment of the musicians, they are much more loosely brushed to give an idea of movement and to capture the texture of their tutus. As a portrait the work shows Degas' attempt to modernize the genre: rather than the traditional, formal pose of the sitter in isolation, Dihau is portrayed in his usual environment, surrounded by other figures who are as strongly individualized as he.

A similar work by Degas is *Musicians in the Orchestra*, which was originally painted in 1870-71 and then reworked c.1874-6, when the artist added a seven inch strip along the top. This allowed him to show the dancers full length, rather than cut-off as before, and reflects his increased interest in dancers as a primary subject. In contrast to the earlier painting, the musicians are seen from behind and so no longer form the centrepiece of the work.

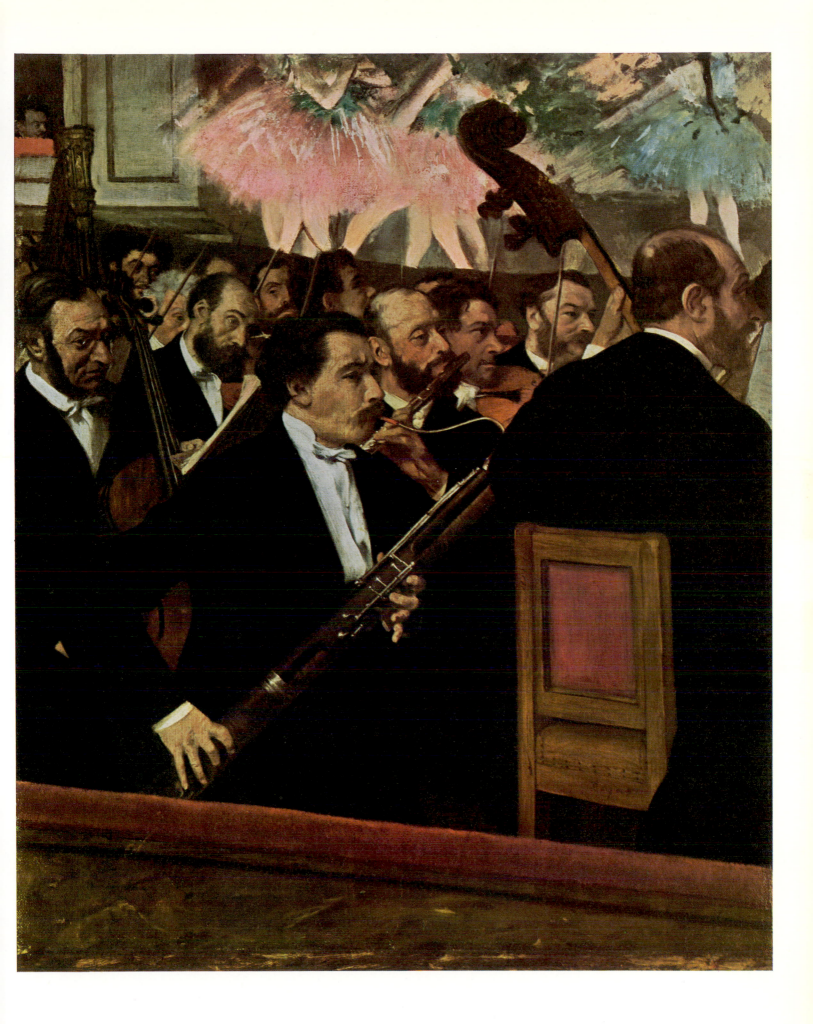

CLAUDE MONET (1840-1926)
The Thames below Westminster

1871. Oil on canvas, 47 x 73 cm. London, National Gallery

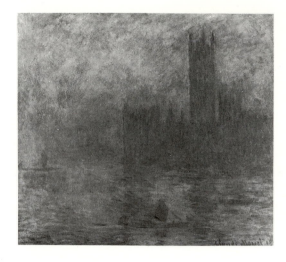

Fig. 18
Monet
Towers of
Westminster
1903. Oil on canvas.
Le Havre, Musée des
Beaux-Arts

Following the outbreak of the Franco-Prussian War in July 1870, in September Monet fled with his family to London, his Republican politics giving him little cause to fight for the survival of the Empire. He stayed in London until May 1871, when he moved on to the Netherlands before returning to France in the autumn. This first trip to the capital was neither particularly happy nor productive, and Monet painted only a few canvases: of the Thames, Green Park (Fig. 19) and Hyde Park. This is the best of the works, showing the Houses of Parliament shrouded in fog. He later came to like the city, returning on several occasions (Fig. 18), and once told the dealer René Gimpel: 'I only love London in winter... without its fog London would not be a beautiful city. It is fog that gives it its wonderful breadth. Its massive, regular blocks become grandiose in this mysterious cloak'. The constant, diffuse lighting unites the painting and softens the contours, while giving a blue tinge to the Parliament buildings. The subtle variations of colour and gradations of tone in the sky merge almost seamlessly with those of the water, the two separated only by the bridge. Apart from the green of the trees and their reflections and the streak of red on a boat hull, the colour scheme is dominated by blues, violets and purples.

The work was exhibited in 1873 in London by the dealer Paul Durand-Ruel, whom Monet first met on this trip. Durand-Ruel, who had earlier bought works of the Barbizon School, was to be an important contact for Monet, giving him a sorely needed degree of financial security. Another refugee at this time was Pissarro, with whom Monet visited the galleries of London, in particular seeing landscapes by Constable and Turner. Both Englishmen were important precursors of Impressionism in so far as they attempted to capture changing effects of light and climate and to work in the open air. Monet was, however, generally dismissive of any perceived similarity between his own work and that of Turner.

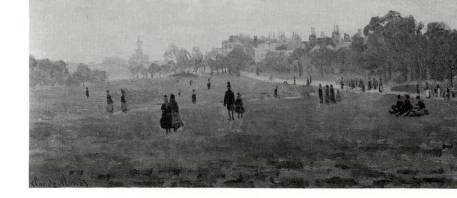

Fig. 19
Monet
Green Park
1871. Oil on canvas,
34 x 73 cm. Philadelphia,
Philadelphia Museum
of Art

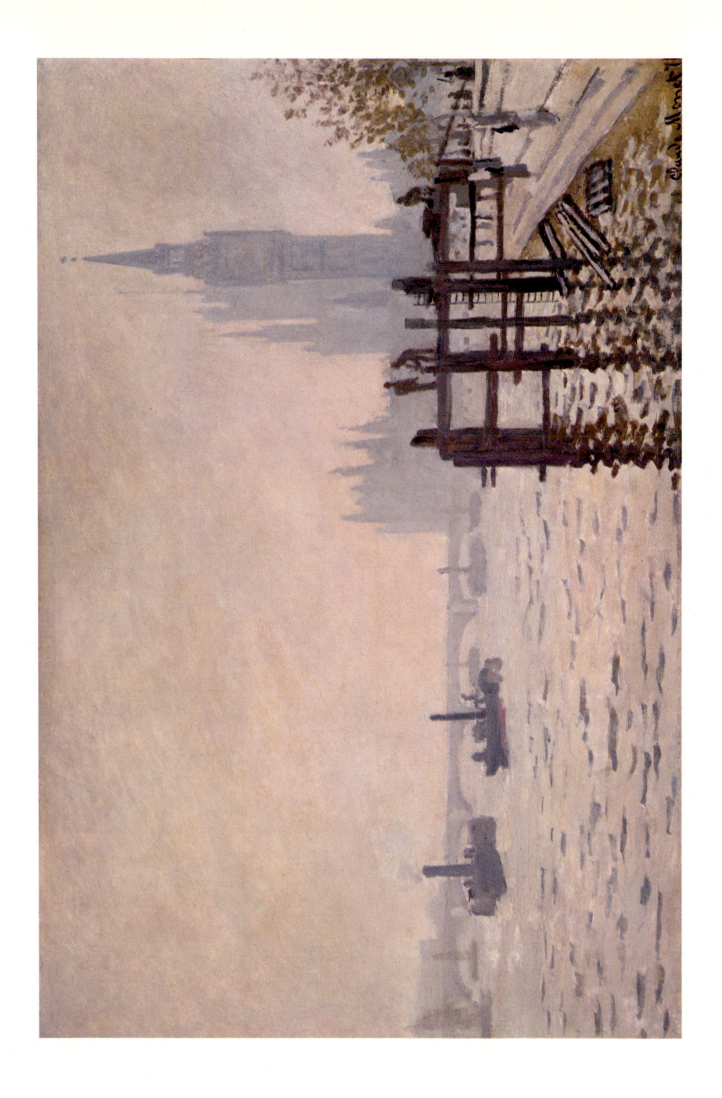

CAMILLE PISSARRO (1831-1903)
Lordship Lane Station, Dulwich

1871. Oil on canvas, 46 x 73 cm. London, Courtauld Institute Galleries

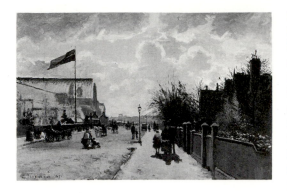

Fig. 20
Pissarro
Crystal Palace
1871. Oil on canvas,
48 x 74 cm. Chicago,
Art Institute of Chicago

Having first moved from his home at Louveciennes to Montfoucault in Brittany in front of the Prussian advance during the Franco-Prussian War, Pissarro finally fled to England with his family in December 1870. He remained in London, where Monet was also staying, until June 1871. The family first stayed at Lower Norwood and then settled at Upper Norwood: Pissarro had three sets of relations in this area. This painting was for a long time known as Penge Station, Upper Norwood until it was correctly identified as showing Lordship Lane Station. The station, since demolished, was on the Crystal Palace High Level Railway, opened in 1865, and Pissarro painted this view from a footbridge. The line terminated at Crystal Palace High Level Station, near to which the Crystal Palace of the 1851 Great Exhibition had been rebuilt (1852-4), and Pissarro painted several views of the palace and surrounding area during his stay in London (Fig. 20). The Palace provided a focus and boost to the local community, and new rows of houses are visible in the left of the work. Instead of the road or pathway that dominates many of his paintings, Pissarro here made the railway and train the central feature, and this was the first Impressionist painting to do so. The entire work shows Pissarro determinedly concentrating on a modern, rather drab theme: either side of the track are featureless expanses of scrubland beneath a grey, overcast sky. It portrays a typical development in contemporary society: the track cuts through the landscape, so triggering the growth of suburbs along its path. Because of the common theme and focus, this picture has often been compared with Turner's famous, *Rain, Steam and Speed: The Great Western Railway* (Fig. 21), which Pissarro would have seen in London. However, where Turner used dramatic, swirling colours and a dynamic composition, Pissarro rendered the scene in an entirely matter-of-fact manner: here it is ordinary and everyday, rather than mysterious and new.

Fig. 21
Turner
Rain, Steam and
Speed: The Great
Western Railway
1844. Oil on canvas,
91 x 122 cm. London,
National Gallery

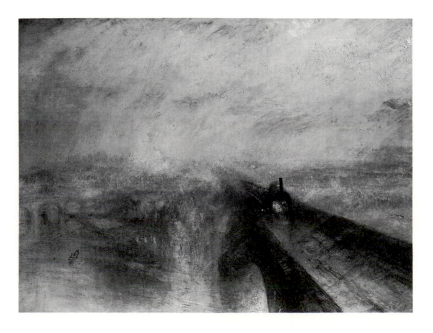

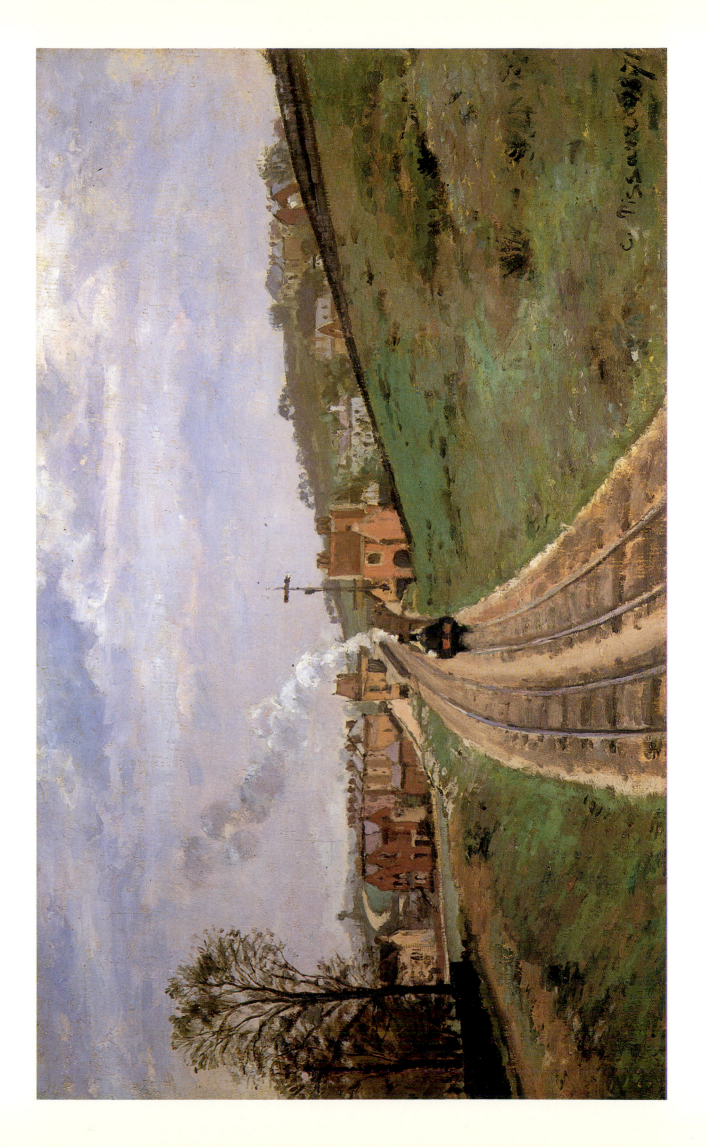

15

BERTHE MORISOT (1841-95)
The Cradle

1872. Oil on canvas, 56 x 46 cm. Paris, Musée d'Orsay

Fig. 22
Cézanne
A Modern Olympia
1872-3. Oil on canvas,
46 x 55 cm. Paris, Musée
d'Orsay

Though her works had always been accepted at the Salon, Morisot decided to take part in the First Impressionist Exhibition of 1874. She showed nine works there: a pastel, watercolours and some oils, of which this was one. The painting is beautifully composed and executed and shows Morisot's sister Edma watching over her newly born daughter, Blanche. Edma herself had once painted but gave it up when she married in 1869. Her pose, with her head resting on her hand, mimics that of the sleeping baby, whose figure is seen through the misty veil of the cradle. The delicacy of the brushwork in achieving the latter effect is characteristic of Morisot's work and became more noticeable in later paintings. Largely dominated by tones of white and black, the contrasting colour scheme gives the work a strong structure, which is further enhanced by the balanced diagonals of the cradle veil in the foreground and the curtain in the background. The fragile, intimate scene perfectly evokes both the innocence of childhood and its transience: the baby is protected from the adult world by nothing more than a light, diaphanous veil.

At the First Impressionist Exhibition this work was shown alongside Cézanne's *A Modern Olympia* (Fig. 22) an emphatically erotic reworking of Manet's *Olympia*, and this produced an extreme contrast in both style and subject-matter between the two works. Morisot's old teacher, Joseph-Benoît Guichard, wrote an appalled letter to the artist's mother after seeing her work placed in such a 'pernicious milieu'. Like that of the other artists participating in the Exhibition, Morisot's work was not well received, and she sold nothing. The exhibition did, however, allow her to show a wider range of her paintings than would have been possible at the Salon, and this was one of the incentives for her participation in later exhibitions (she took part in all but the Fourth Impressionist Exhibition of 1879).

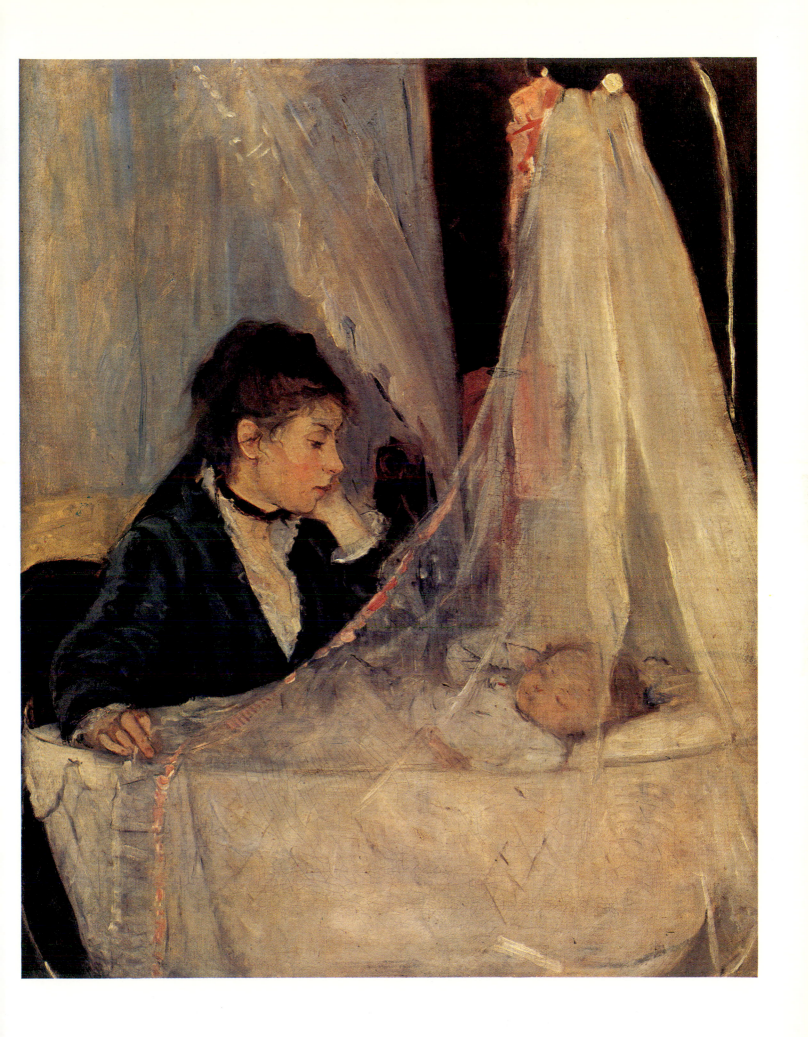

CAMILLE PISSARRO (1831-1903)
Entrance to the Village of Voisins

1872. Oil on canvas, 46 x 55 cm. Paris, Musée d'Orsay

Between 1869 and 1872, except for the interruption of war, Pissarro lived in Louveciennes (see Plate 26). Nearby is the village of Voisins, shown here, where Sisley later lived. This is characteristic of many of Pissarro's paintings in that its composition is divided and structured by the central road. The viewpoint is such that over half of the work is covered by the luminous area of sky. Compared to earlier works by Pissarro it shows the influence of Monet in the bright palette and light brushstrokes. There is a strong, almost symmetrical, organization to the work, which is underpinned by the two groups of trees either side of the road and the long shadows cast by those on the left. The taller complex of buildings tempers the otherwise rather rigid symmetry, while the horse and wagon dawdling along the road and the scattered figures enhance the serenity of the painting. The result is an unassuming image typical of the artist's works of this period. It owes much to the paintings of Corot, who had advised Pissarro in the 1850s and indeed in composition and spirit it is similar to Corot's *Church of Marissel* (Fig. 23). Pissarro was one of the few Impressionists to favour such rustic scenes in preference to those of city life and leisure.

Fig. 23
Corot
Church of Marissel
1866. Oil on canvas,
56 x 43 cm. Paris, Musée
d'Orsay

17

CLAUDE MONET (1840-1926)
Impression: Sunrise

1873. Oil on canvas, 48 x 63 cm. Paris, Musée Marmottan

This work was painted from a hotel window at Le Havre in 1873 (Monet later dated it incorrectly to 1872). It was one of the nine works that he showed at the First Impressionist Exhibition of 1874. Of all those displayed there, this is probably the most famous picture, not so much because of any crucial status within Monet's oeuvre, but rather for the criticism it attracted from the reviewers, which gave rise to the name of the movement. On 25 April, ten days after the exhibition had opened, an article appeared in the satirical journal *Le Charivari* in which the critic Louis Leroy described a fictitious conversation between two visitors. One of them was a landscape painter who, while looking at this work, exclaimed: 'Impressionism, I knew it; after all I'm impressed so it must be an impression...What freedom! What ease of workmanship! Wallpaper in its embryonic state is more finished than this seascape!' The article was entitled 'The Exhibition of the Impressionists', and the label stuck thereafter, as well as being used by such other critics of the exhibition as Castagnary.

Despite its notoriety the painting is in some ways untypical of Monet's own work of this period and of Impressionism more generally. It shows little of the Impressionist treatment of light and colour. The colours are very restrained and the paint is applied not in discrete brushstrokes of contrasting colours but in very thin washes. In some places the canvas is even visible and the only use of impasto is in the depiction of the reflected sunlight on the water. The painting is strongly atmospheric rather than analytical and has a spirit somewhat akin to Turner's works. Nevertheless, it does illustrate particularly well one of the features of Impressionist painting that was thought so revolutionary. The technique is very 'sketchy' and would have been seen as a preliminary study for a painting rather than a finished work suitable for exhibition. (Monet himself saw the work as unfinished, and it was for that reason that he adopted the title 'Impression' to distinguish it from such works as his other view of Le Havre in the same exhibition, though this too lacks the finish then expected.) In this work Monet stripped away the details to a bare minimum: the dockyards in the background are merely suggested by a few brushstrokes as are the boats in the foreground. The whole represents the artist's swift attempt to capture a fleeting moment. The highly visible, near abstract technique, compels almost more attention than the subject-matter itself, a notion then wholly alien to viewers.

PAUL CÉZANNE (1839-1906)
Dr Gachet's House at Auvers

c.1873. Oil on canvas, 46 x 38 cm. Paris, Musée d'Orsay

Fig. 24
Cézanne
Temptation of St
Anthony
1869. Oil on canvas.
Zurich, Fondation E G
Bührle Collection

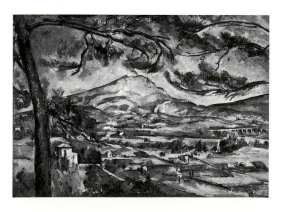

Fig. 25
Cézanne
Mont Sainte-Victoire
1885-7. Oil on canvas,
67 x 92 cm. London,
Courtauld Institute
Galleries

Both in style and subject-matter this work represents a radical departure for Cézanne and reflects the influence of Pissarro, with whom he was then working. His preceding paintings were mostly executed in dark, earthy colours and had imaginary subjects (Fig. 24). In the spring of 1872 he moved with his family to Pontoise, where Pissarro was already settled. Late in 1872 he moved to nearby Auvers, where the collector and patron Dr Paul Gachet lived, and he stayed there until 1874. Working alongside Pissarro in both Pontoise and Auvers, Cézanne learnt to paint directly from nature, adopting the palette and execution of his older mentor. He used much lighter tones and built up the work with separate strokes rather than in a thick, broad impasto. Even the composition of this work owes something to Pissarro, with the road dominating the foreground. Pissarro had great faith in his young colleague, and commented, 'If, as I hope, he stays some time at Auvers, he will astonish a lot of critics who were in too great haste to condemn him'.

Cézanne took part in the First Impressionist Exhibition of 1874 and the Third of 1877. At both his paintings received the most contemptuous reviews of any of the participants. At the First Exhibition one critic said 'Of all known juries, none ever imagined, even in a dream, the possibility of accepting a work by this painter'. Even some of the other Impressionists, such as Degas, felt uncomfortable about having his work in the shows because of the ridicule it attracted. Not until the 1890s was his painting seriously considered and for years he made repeated but hopeless attempts to get his work accepted at the Salon. Though influenced by Pissarro's Impressionist style at the time of this work, his painting never achieved the lightness of touch favoured by other Impressionists and his concern for structure remained evident (and is also a feature of Pissarro's work to a lesser extent). It was precisely this latter quality, achieved particularly through planar composition and short, parallel brushstrokes (Fig. 25), that prompted the development of Cubism in the early twentieth century and thus the complete overthrow of the Impressionist aesthetic.

19

EUGÈNE BOUDIN (1824-98)
Beach at Trouville

1873. Oil on panel, 15 x 30 cm. London, National Gallery

Boudin's connection with Impressionism is primarily as a precursor, though he did take part in the First Impressionist Exhibition of 1874. He was especially important as an influence on the young Monet, whom he first met in 1858 and encouraged to work in the open air. Boudin painted a large number of works at Trouville (Fig. 26), as well as similar scenes of other resorts nearby, such as Deauville, and coastal towns in Belgium and the Netherlands. Trouville is on the northern coast of France near to both the Seine estuary and to Honfleur, where the artist was born. Like the other towns in the area, it had expanded greatly in the mid-nineteenth century because of its popularity as a tourist destination, particularly for Parisians but also for the English. As was the case in the rest of the region, after being praised by both artists and writers for its undiscovered charm, the town rapidly altered as tourists flocked there to enjoy the sea air and its accompanying activities. Boudin was one of the first to portray the bourgeoisie at leisure in art, and many of his scenes have the same characteristics as seen in this one: elegantly dressed figures crowded along the shore among a scattering of parasols. Often he organized his compositions such that the emphasis was more on the sky than on the people beneath – like Constable before him, he made numerous cloud studies, especially in watercolour and pastel. He worked mostly in a small format, which facilitated painting outside (though he probably finished some of the oils in his studio). In the 1850s and early 1860s his style was meticulous and studied. By the late 1860s and increasingly thereafter, his brushwork became looser and more spontaneous, similar to the Impressionist manner, as seen here. Monet himself painted at Trouville and the neighbouring coastal area.

Fig. 26
Boudin
Beach at Trouville
1865. Oil on canvas,
18 x 27 cm.
Private collection

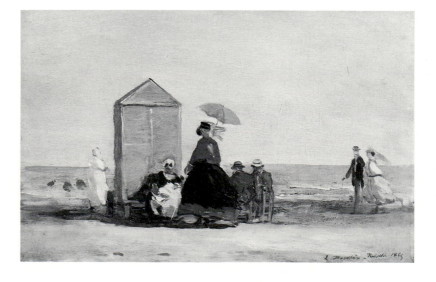

EDGAR DEGAS (1834-1917)
The Ballet Rehearsal

1873-4. Oil on canvas, 65 x 81 cm. Paris, Musée d'Orsay

This is the largest and possibly the earliest of a group of three works on this subject, all with very similar compositions, the other two being in the Metropolitan Museum in New York. It is the only painting known by Degas to have been painted in grisaille (tones of grey), and his use of this manner has been explained by the fact that he was at this time trying to establish himself in England through the publication of engravings, in this case unsuccessfully for the *Illustrated London News*. A design in grisaille allowed the engraver to transfer it onto the printing plate without the distractions of colour. Shown at the First Impressionist Exhibition of 1874, the unusual medium and soft manner of execution led some visitors to mistake it for a drawing and it was particularly praised for its extraordinary effects of light and shade.

In the other two versions there is a dancing master in the centre, next to the dancer stretching with her arms behind her head. There is also another male onlooker slouched on a chair next to the one in the top hat. Both figures were originally in this painting also and, though later erased, their traces are still visible. The absence of the dancing master renders the work somewhat baffling: the dancers all appear to be relaxing apart from the pair at the front of the stage, who were originally being instructed by the master. Without any apparent direction, their activity seems somehow purposeless. Furthermore, the depiction of the seated man in the top hat, previously quite explicable as an unofficial spectator, now appears ambiguous, indeed disconcerting. Positioned as though he ought to be somehow involved in the action, he merely stares impassively at the scene before him. This inclusion of a male spectator is quite common in other of Degas' images of dancers and presages the later, more intimate scenes of women at their toilet, in which the presence of the male onlooker is merely implied through the perspective of the viewer.

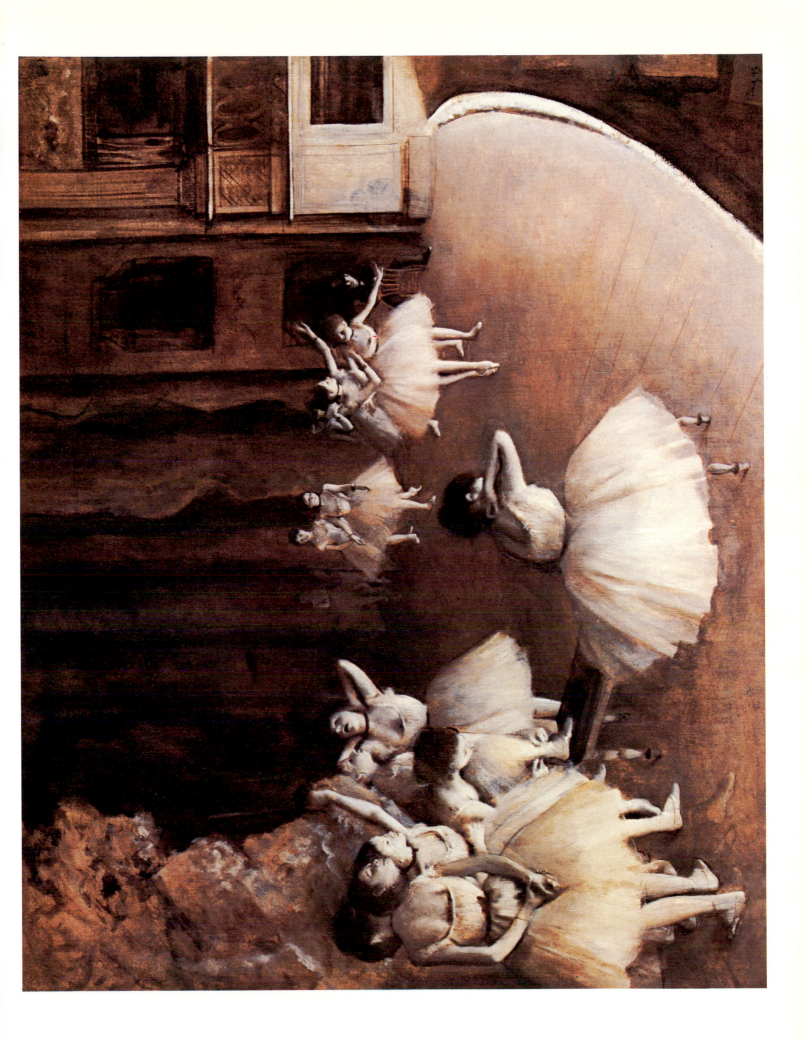

EDGAR DEGAS (1834-1917)
The Dance Class

1873-5/6. Oil on canvas, 85 x 75 cm. Paris, Musée d'Orsay

Though Degas had been treating the subject since 1870, this is his first fully accomplished ballet work. It was painted in two stages: from late 1873 to mid-1874 and then in 1875-6, when it was substantially reworked. There is a variant in the Metropolitan Museum in New York. X-ray photographs and associated drawings reveal that the painting originally showed the foreground dancer with a fan posed looking out at the viewer and leaning against the piano, while the unidentified dance master was seen from the back. Some features of this original dancer can be seen beneath the present one: the dark brown patch on the fan was originally part of the hair of the first figure. The anonymous figure of the dance master was replaced with that of Jules Perrot, whom the artist had probably first met in 1874. Perrot had been a famous dancer at the Opéra and had also worked in Russia, before later becoming a teacher. Degas thus transformed the original work into a kind of homage to Perrot, turning the foreground dancer away from the viewer so as not to distract from his figure. Her present position, watching Perrot, serves to direct the eye towards the centre.

This reworking of the image is typical of Degas' laborious method, and signs of alteration are also evident in many other works. The setting was probably a room in the old opera house in the rue Le Peletier, which had burnt down in 1873. Though supposedly a class, hardly any of the dancers are actually paying attention to Perrot. The dancer in the foreground, seated on the piano, is scratching her back, while the one at the far end of the room above the rest is adjusting her choker. Most of the others are similarly distracted. In the background, to the right, can be seen some of the dancers' mothers, while the small dog in the foreground adds a further incidental detail.

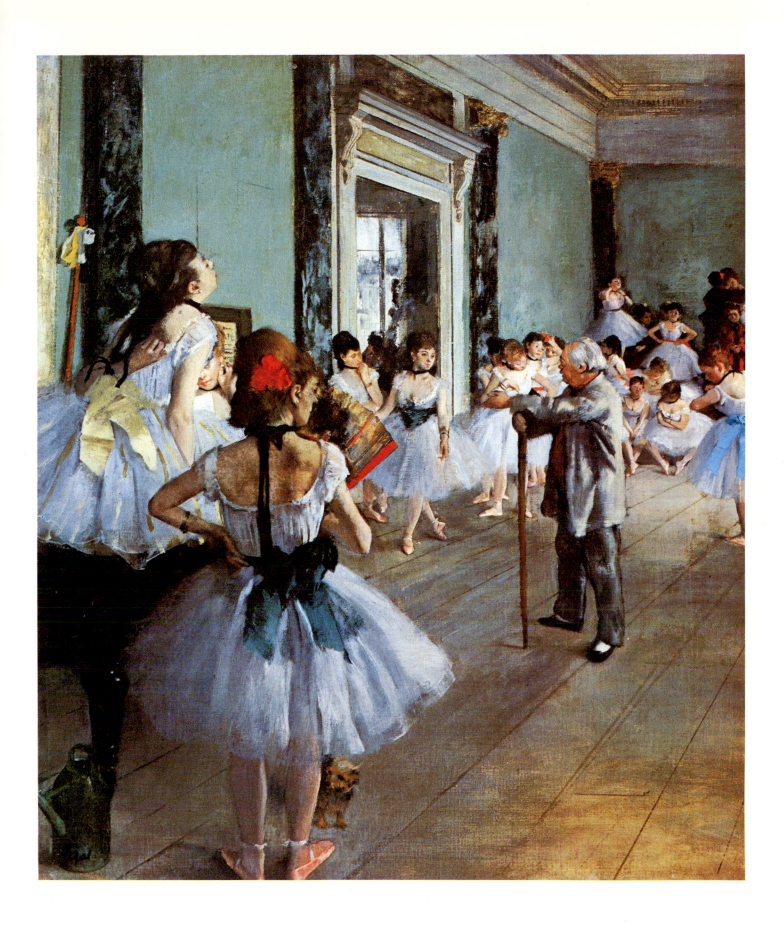

CLAUDE MONET (1840-1926)
Bridge at Argenteuil

1874. Oil on canvas, 60 x 80 cm. Washington, DC, National Gallery of Art

Argenteuil is situated on the Seine, nine kilometres to the north-west of Paris, and Monet rented a house there in 1871 soon after his return to France after the Franco-Prussian War. He remained there for six years and rarely travelled elsewhere, in contrast to the restless years of the preceding period. Monet's work developed considerably at Argenteuil as did that of other Impressionist painters. At various times Renoir, Sisley, Caillebotte and Manet joined Monet there, and the common purpose and style of their work in the period 1873-5 marks it as one of the highpoints of the movement. At Argenteuil the river is crossed by two bridges: one an old wooden structure supported on stone piers and used for pedestrian and road traffic, and the other a more recent steel and concrete railway bridge. The latter typically exemplified the perceived modernity of new architecture and technology; both appear in Monet's works of this time.

The road bridge shown here was more suited to quiet, contemplative images, and the calmness of the scene is emphasized by the sailing boats moving steadily along the river. (Argenteuil, like many of the Seine towns near Paris, was a popular destination for holiday-makers from the capital in the summer.) The depiction of the water illustrates the Impressionist technique of applying discrete brushstrokes to build up the image and describe the varying light effects. During this period in Argenteuil Monet began to work on near identical subjects in separate canvases, thus presaging the series paintings of the 1890s and onwards. He painted a variant of this work in the same year from a position a little further down the river from the bridge. He also painted a pair of pictures (1873 and 1874) of the railway bridge in differing weather conditions.

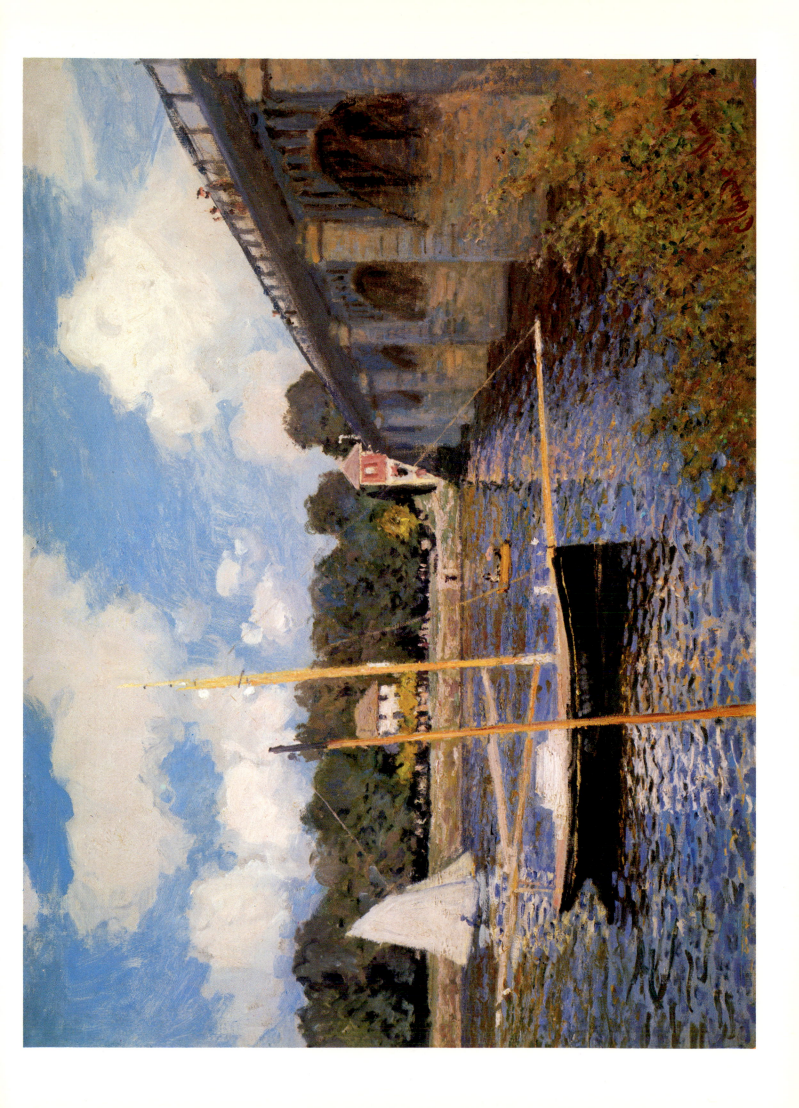

EDOUARD MANET (1832-83)
Monet Painting in his Floating Studio

1874. Oil on canvas, 83 x 104 cm. Munich, Neue Pinakothek

Painted at Argenteuil, this is the more finished and probably the earlier of two attempts Manet made at the subject. In July and August 1874 he spent several weeks at his family's property at Gennevilliers, located on the opposite bank of the Seine to Argenteuil, where Monet was then renting a studio (see Plate 22). Manet painted a canvas of the Monet family in their garden (Fig. 27), a work that captures the care-free atmosphere of the period. The painting shown here depicts the purpose-built boat that Monet used for painting many of his scenes of the Seine. He had taken the idea from the landscape painter Charles-François Daubigny, who had had a similar construction built for the same use. Seated in the little cabin is Monet's wife Camille, who looks on as her husband works. Beneath the shade of the awning Monet paints a scene that can be seen over his left shoulder: the river with houses along its bank and factories in the distance. To the right and in the background can be seen the more usual sort of pleasure boat found on the river.

The style of execution shows the influence of Manet's younger Impressionist colleagues, and the water on the left is painted in broad, distinct brushstrokes of differing colours. However, the freedom of execution is looser than most of Manet's other works of this time and must in part be attributed to the fact that he abandoned the work, as he did the other version. It is said that Manet was reluctant to waste so much of Monet's time by having him sit to him, and thus for his other river scenes he used models whose time he thought less precious. The very sketchy variant of this work shows the two figures more formally posed than here.

Fig. 27
Manet
The Monet Family in their Garden
1874. Oil on canvas,
61 x 100 cm. New York,
Metropolitan Museum of
Art

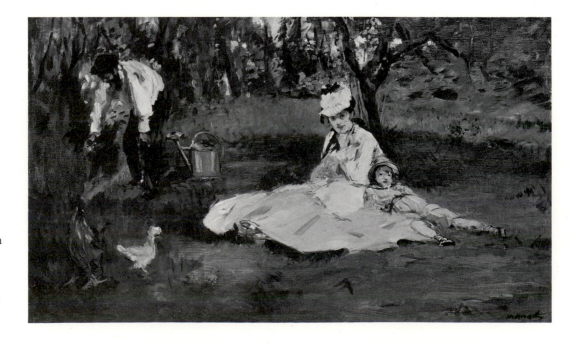

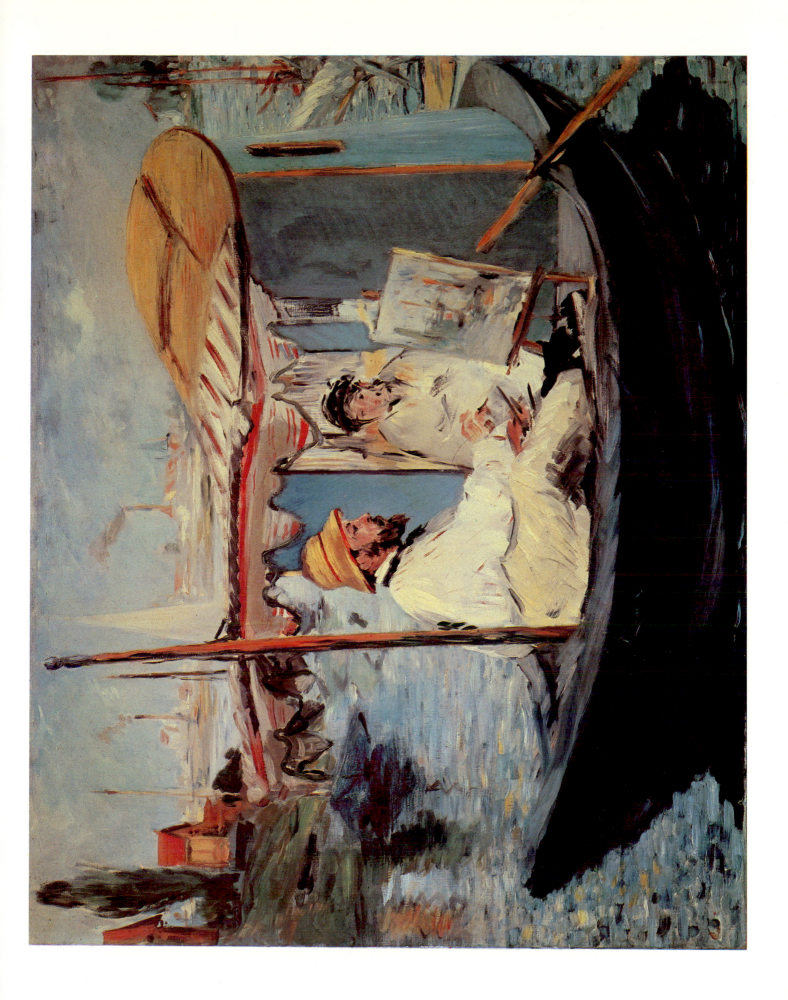

BERTHE MORISOT (1841-95)
The Butterfly Chase

1874. Oil on canvas, 47 x 56 cm. Paris, Musée d'Orsay

Painted just after the First Impressionist Exhibition of 1874, this work shows her sister Edma and her children in their garden at Maurecourt, near Auvers, and is a related composition to the slightly earlier *Hide and Seek* (1873). Morisot often returned to the subject of the suburban garden in other canvases. This picture is dominated by the figure of Edma, who stands out through the solid mass of her white dress, and is depicted as if half posed and half engaged in catching butterflies. Behind her, her daughter Jeanne looks intently on, her interest in the scene conveyed not so much through her face, which has hardly any features, as through her pose. Another child crouches to Jeanne's right, while half hidden behind a small tree sits another figure, perhaps a young boy. The loose, broad brushwork, used to describe the thick foliage, makes the dabs of white in the foreground unclear: they may be flowers or butterflies. The prominent, isolated sapling echoes the theme of childhood in the work and contrasts with the large well-established blossoming tree in the background. Edma holds the butterfly net such that it visually links the two trees, suggesting the relationship of mother to child. The butterfly hunt itself symbolizes the imminent passing of carefree youth. This painting was sold at the auction of Impressionist works held at the Hôtel Drouot in 1875, where it was bought by the naturalist painter Ernest Duez. Morisot fared comparatively well on this occasion, and it was one of her works, *Interior*, that fetched the highest price (480 francs).

25 PIERRE AUGUSTE RENOIR (1841-1919)
La Loge

1874. Oil on canvas, 80 x 64 cm. London, Courtauld Institute Galleries

This work is one of the seven that Renoir showed at the First Impressionist Exhibition of 1874 and is one of his early masterpieces. Showing a box at the theatre, the two models were Renoir's brother, Edmond, and the model Nini (peculiarly nicknamed 'Gueule de Raie', or 'Fish Face'). The subject recurs in Renoir's oeuvre as well as that of Degas and Cassatt (see Plate 42). It had also been treated by earlier artists, such a Daumier, and had appeared in popular caricatures. The choice of a box rather than some other part of the theatre is perhaps due to the framed space that this provided the artist. It is essentially the modern subject that connects the work to Impressionism, as in respect of its execution it bears closer affinities with the work of such earlier painters as Watteau or Rubens than with that of the Impressionists. The treatment of the sumptuous fabrics of the woman's dress and her skin as well as the modelling and polished brushwork are remarkable feats of painting.

In the contemporary society the theatre box was an arena for exhibition, where the women were on display (hence seated forward) and formed part of the public image of their male escort. In this picture the man looks up, not at the stage, but at other boxes to see who else is present and with whom. The critics of the First Impressionist Exhibition devoted much space to this work, and their comments were largely favourable, in contrast to those on most other works. There were differing interpretations of the status of the woman (which Renoir leaves open), who was variously described as an elegant society lady or as a suspect cocotte. Though the work was well received critically it did not sell for the meagre asking price of 500 francs and later entered the collection of Père Martin for 425 francs.

ALFRED SISLEY (1839-99)
Snow at Louveciennes

1874. Oil on canvas, 56 x 46 cm. Washington, DC, Phillips Collection

From 1872 to 1874/5 Sisley lived at Voisins (see Plate 16). The village was outside Louveciennes, west of Paris near the Seine, and was the subject of many of his works in that period (Fig. 28). In particular, it was at this time, beginning in 1872, that he started to paint snow scenes, and these recur throughout the 1870s. Though there are notable exceptions (such as the works of sixteenth- and seventeenth-century Dutch and Flemish artists), most landscapes had traditionally been depicted in the summer, and the Impressionists were one of the first to paint landscapes in snow to any systematic degree. Sisley himself painted numerous images of Louveciennes in the snow in 1874 and in 1872/3 he had painted precisely the same view as this, but in summer. Of the two, this is the more spontaneously and loosely brushed; indeed the canvas is visible along the top edge. In both works there is one solitary figure with an umbrella, here shown shielding herself from the falling snow, which is indicated by the very lightly brushed streaks of white that are visible against the walls and buildings. The brown and orange hues of the buildings, gate and wall on the right, particularly the right-hand window, brighten the grey and white tones that are otherwise dominant. The areas of snow are organized by the structures of the buildings and give it a unity of composition, but also imbue it with an atmosphere of ordered calm: the figure is not so much struggling against the elements as merely acknowledging them. This sense of the inevitable changes of climate, reinforced by Sisley's detached vision, also pervades other works by the artist.

Fig. 28
Sisley
Sentier de la Mi-côte,
Louveciennes
1873. Oil on canvas,
38 x 47 cm. Paris,
Musée d'Orsay

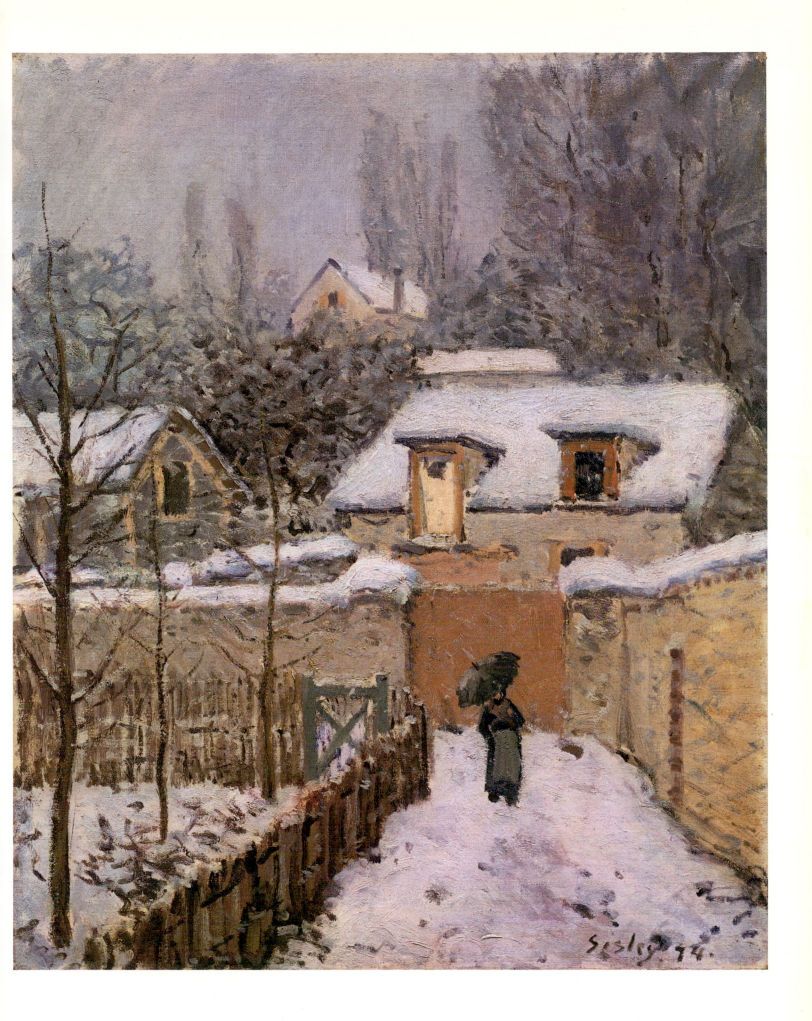

ALFRED SISLEY (1839-99)
Inn at East Molesey with
Hampton Court Bridge

1874. Oil on canvas, 51 x 69 cm. Private collection

Soon after the close of the First Impressionist Exhibition, in which Sisley had participated, the artist was invited to travel to England by the baritone and collector Jean-Baptiste Faure (1830-1914), who was to perform there. In return for his expenses Sisley was to give Faure six of those works painted while abroad. Faure had been an early supporter of the Impressionists, especially Sisley, and eventually came to own nearly 60 works by the artist. While in England from July to October 1874 Sisley painted some 15 works, of which one shows the Thames with Charing Cross bridge, and the others depict scenes around Hampton Court and nearby East Molesey, both on the Thames. While working in this area he stayed at the Castle Inn shown here by the bridge.

Sisley's choice of a riverside location for his works gave him the opportunity to paint the same types of scene as he had done earlier at Argenteuil and Bougival in France. In particular, the regatta at Hampton Court presented an animated subject for several of the canvases. One of the recurrent features in the series is the bridge that appears in this work. It was constructed in 1865 and contrasted with the much older buildings of the area, such as the Tudor palace. Made of brick and iron (and thought ugly by contemporaries), its castellated end is seen here, and this design was intended to echo the architecture of the palace. Under the first arch of the bridge are moored a number boats, which highlight the pervasive theme of leisure in the painting. The scene was deliberately chosen for its absence of picturesque qualities, and is dominated by the sweep of the brightly lit riverside path on the foreground, dotted with a handful of figures, and by the expanse of sky. This latter element exemplifies something Sisley wrote in 1892: 'Objects should be bathed in light just as they are in nature...the sky must be the means of doing so (the sky cannot be a mere background). On the contrary, it not only helps to add depth through its planes (for the sky has planes just as the ground does), it also gives movement through its shape and by its arrangement in relation to the effect or composition of the picture.' These pictures of rivers were among Sisley's last and they constitute an important stage in the development of Impressionism, using bold colours and brushwork to capture light and atmosphere.

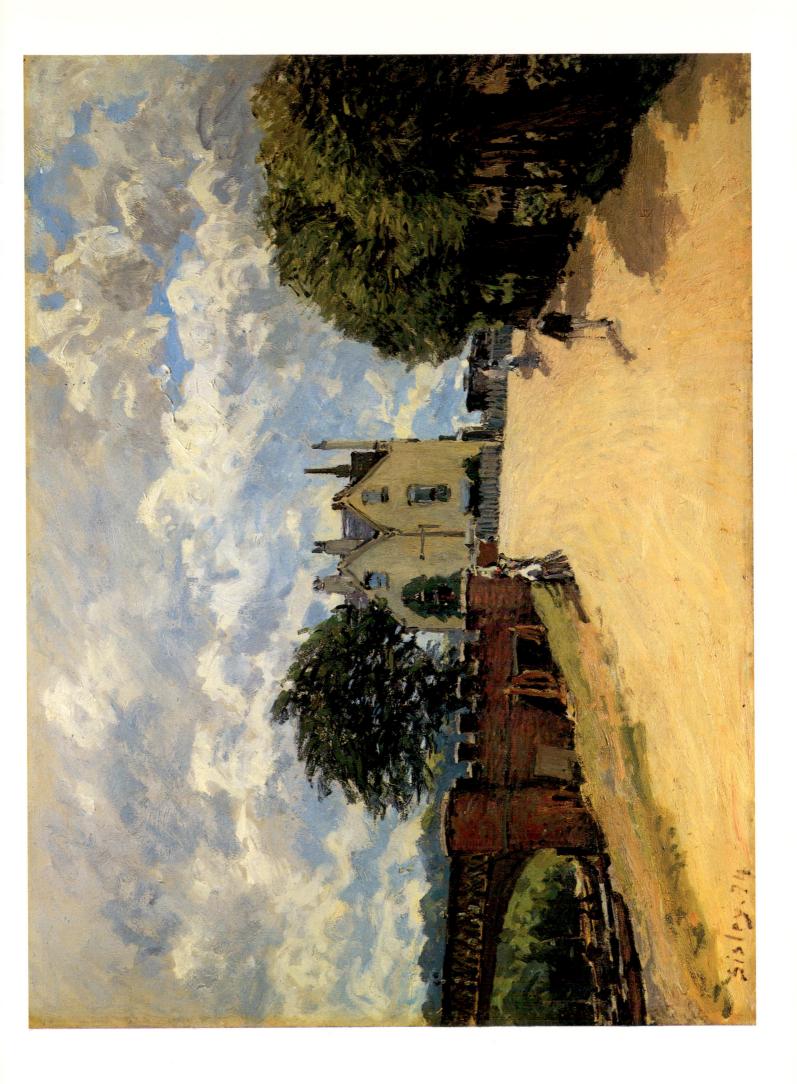

ALFRED SISLEY (1839-99)
Misty Morning

1874. Oil on canvas, 50 x 61 cm. Paris, Musée d'Orsay

This image of a kitchen garden was painted at Voisins, near Louveciennes, and is a remarkable feat of painting, showing Sisley's ability to capture light and mood. The canvas is largely executed in thin paint except for the flowers in the foreground, which are impasted in thicker dabs of colour. The diffuse, dim lighting of the mist softens forms, such that the background is merged together in a blue/grey haze. The further back the objects are situated the less detailed, coloured and visible they become and this gives the work its depth. The clump of flowers in the foreground catches the eye and provides a focus to the work, but also leads one's gaze towards the crouching figure behind, who is perhaps busy digging vegetables. All of these features reflect Sisley's comment of 1892 that 'The subject, or theme, should always be represented in a simple and comprehensible form, which grasps the spectator' who 'should be drawn – by the elimination of superfluous details – along the road the painter shows him and should see first whatever caught the artist's eye. Everything should play a part: form, colour, treatment'. Despite Sisley's detached approach to his subject, the scene is imbued with a spirit of quiet calm, and this fulfills the artist's comment that 'It is the painter's emotion that brings it [the painting] to life and it is that same feeling that awakens the emotion of the spectator'. Sisley's concentration on landscape, incorporating only a few peripheral figures, and his ability to capture such effects of weather and mood brings his work of this period close to that of Monet, though the latter was generally bolder and more experimental.

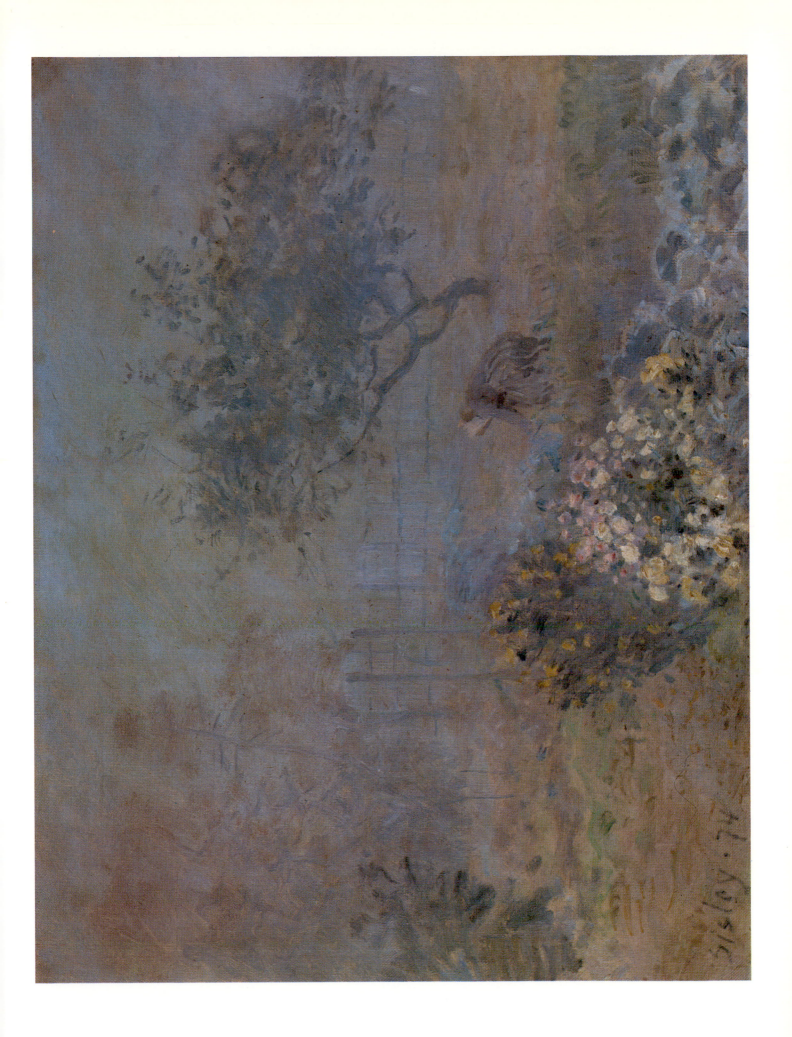

GUSTAVE CAILLEBOTTE (1848-94)
The Floorscrapers

1875. Oil on canvas, 102 x 146 cm. Paris, Musée d'Orsay

This work was shown at the Second Impressionist Exhibition of 1876 and treats a novel subject in art, showing three men planing a new floor. Caillebotte made numerous careful preliminary sketches and also painted a variant on the same subject. The shine is due to the water put down to minimize splintering. The subject, coupled with the narrow range of colours, links the work with the images of workers painted by such Realists as Courbet, as well as with Impressionism. Nevertheless, while the Impressionists were not afraid to depict themes deemed unworthy of art by their contemporaries, pictures of workers engaged in their labours are rare, making this picture all the more distinctive. At the time of its exhibition the work was criticized for its 'vulgarity'.

The painting has a strong perspectival structure, in this case created through the lines of the floorboards. The room, with its elegant panelling and attractive ironwork balcony, is clearly indicated to be that of a wealthy owner. Ornate rooftops can be glimpsed through the window, further suggesting that the house is situated in a desirable part of the city. The clear, severe lines of the room, strengthened by the rectilinear geometry of the panelling, create a neat, ordered setting that is made to appear disturbed by the presence of the workers, all of whom are given similar features. Stripped to the waist, with their clothes cast casually off in a corner and a bottle of wine and glass on the floor, they highlight the disparity between their own social class and that of the house owner. The work was donated to the State by the artist's family in 1894, soon after his death, and so joined the numerous other Impressionist pictures that Caillebotte had collected and bequeathed to the State. The acceptance of part of the bequest, the first Impressionist works to enter a public museum, caused much public outcry, showing to what degree they were still seen as revolutionary.

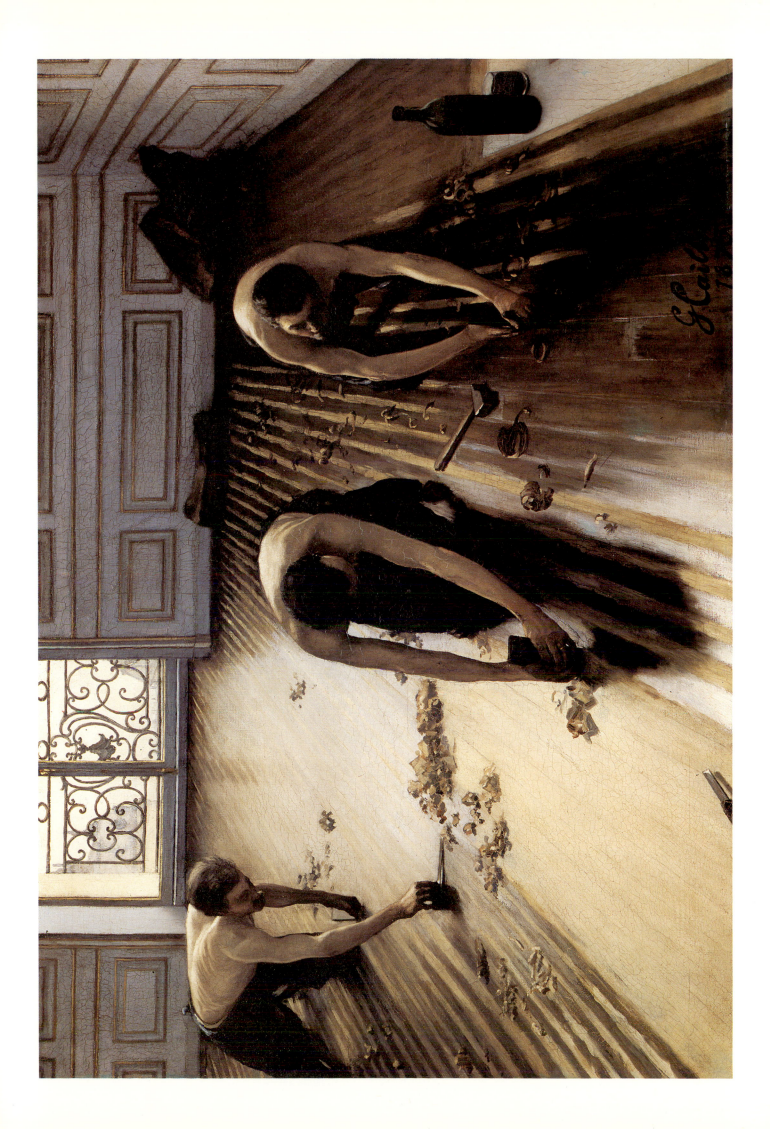

30 EDGAR DEGAS (1834-1917)
L'Absinthe

1875-6. Oil on canvas, 92 x 68 cm. Paris, Musée d'Orsay

The two figures in this work were modelled on members of the Impressionist circle – the artist Marcellin Desboutin, and the actress and model, Ellen Andrée – and are shown at the Nouvelle-Athèns Café, a favourite meeting place at this time. Desboutin was painted by Manet in 1875 and Andrée appears in works by both Renoir and Manet. Degas did not finish the work in time for the Second Impressionist Exhibition of 1876, but it appeared at the Third of 1877. Despite its realistic basis, the scene cannot be seen as merely a slice of Impressionist life. It attracted considerable criticism when it was exhibited, especially on its display in London in 1893. On this occasion the conservative English artist Walter Crane claimed it to be 'a study of human degradation, male and female'. What many saw was a depiction of alcoholism, which became a public issue in France during the Second Empire. Right wing politicians had exploited it as a means of explaining away broader social and economic difficulties, while a growing temperance movement had also emerged. Further evidence of public sensitivity to the subject is indicated by the fact that Manet's much earlier picture of an absinth drinker (1859) was refused by the Salon for its uncompromising naturalism.

Absinth (identified as Andrée's drink by its colour and the presence of a carafe of water) was the most popular of spirits in France at this time. With the increasing demand for it there arose an almost mythical notion of its addictive, debilitating effects, which are suggested here by the slouching pose and vacant, lifeless expression of the woman. The full shadows behind the figures and the grey palette furthermore indicate that the scene is set in the morning. Typical of Degas' treatment of the subject is his detachment and the way in which the viewer is made to feel uncomfortably close to the figures: the viewpoint seems to be from the adjoining table. The large expanses of bare table top draw the eye swiftly from the cursorily sketched newspapers in the foreground towards the main subject. The artist's objective, pitiless gaze is echoed by the psychological distance between the two figures: no clues are given as to whether there is any relationship between them or whether they are merely seated together.

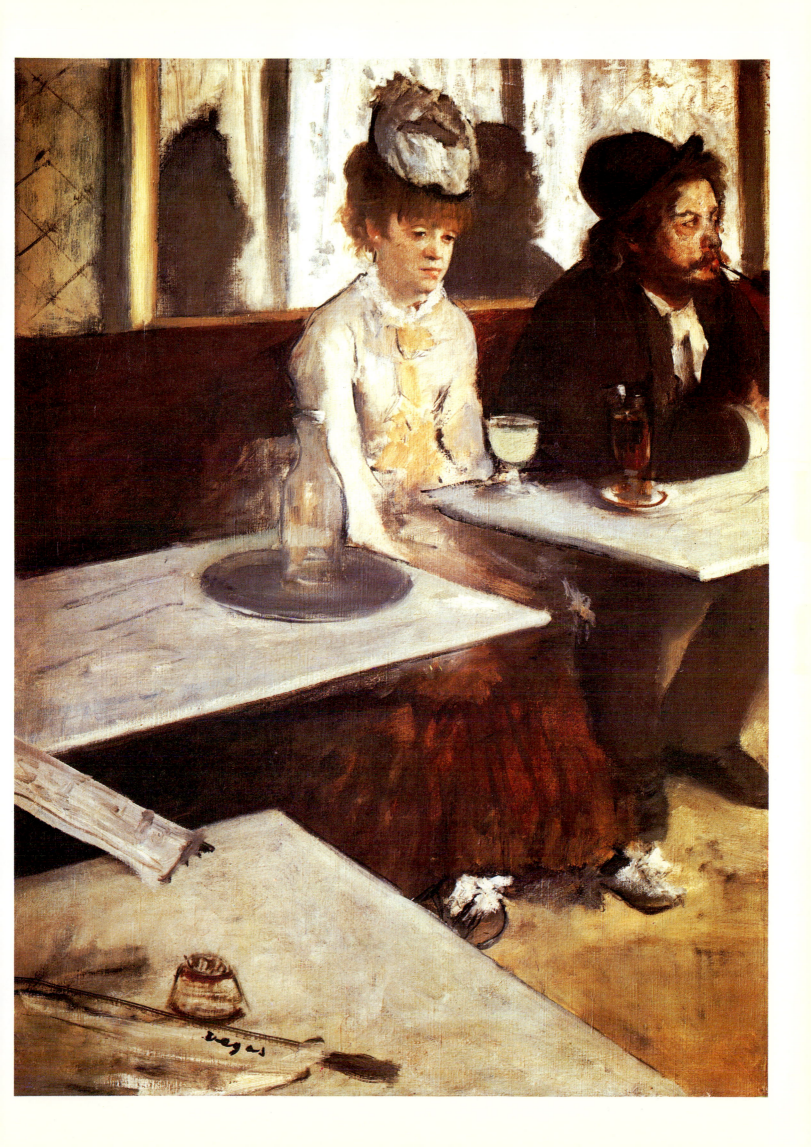

31 GUSTAVE CAILLEBOTTE (1848-94)
The Pont de l'Europe

1876. Oil on canvas, 131 x 181 cm. Geneva, Musée du Petit Palais

Shown at the Third Impressionist Exhibition of 1877, this picture is typical of Caillebotte's work until about 1878/9, when his brushstrokes became broader and his subjects more personal. The composition is dominated by the bridge, which was built in 1868 to connect the yards of the Gare Saint-Lazare. Technology was then thought an inappropriate subject for art, though it appears in various Impressionist pictures. Monet in particular painted several images of the station in the following year (see Plate 36), while Caillebotte himself painted a variant of this work.

The bridge provides a rigid diagonal perspective, which draws the eye rapidly into the composition. The harsh lines of the painting reflect those which had recently been imposed on Paris during the city's redevelopment by Baron Georges Haussmann. In the background are blocks of elegant houses, contrasting with the stark ugliness of the bridge. Caillebotte seems intent on emphasizing the inhuman aspect of technology, both through its scale and lack of relation to the figures. This is further communicated through the pallid, light-bleached colours. Above the heads of the figures a plume of smoke rises from a train passing underneath, while to the right, through the gaps in the metal girders, yet another bridge and an engine can be seen. The man on the right thus looks out not at an attractive landscape or river but at a bleak railway yard. His dress marks him as a worker, in contrast with the two fashionably attired figures walking briskly towards the viewer. The man in the top hat is based on Caillebotte himself and is derived from a photograph taken at this time. He depicts himself in the role of a flâneur, or idle, wandering observer, a character common in contemporary naturalist literature. The identity of the figures, the sense of motion (further enhanced by the walking dog) and the dynamic perspective combine to create a convincing image of the bustle and social mixture of city life.

PIERRE AUGUSTE RENOIR (1841-1919)
Dance at the Moulin de la Galette

1876. Oil on canvas, 131 x 175 cm. Paris, Musée d'Orsay

The Moulin de la Galette in Montmartre, named after one of the three windmills in the neighbourhood, held open-air dances every Sunday, and these would start in the early afternoon and carry on until midnight. It provided Renoir with the subject for this, his most ambitious work of the period. From the lengthy account of the picture given by Renoir's friend Georges Rivière, many of the models for the figures can be identified (though not always their positions). The three men seated at the right are Rivière himself and the painters Pierre Franc-Lamy and Norbert Goeneutte. Next to them are one of Renoir's models and her sister, while to the left the two most prominent dancers are another of Renoir's models, Margot, and the Cuban painter Pedro Vidal de Solares y Cárdenas. Several of the other dancers were also friends of Renoir. Rivière noted that the women in this work, whom the artist had patiently coaxed into posing for him, were of working class origin, i.e. of the type that would normally frequent such dances (Montmartre was a poor, fairly run-down area). Caillebotte bought the painting, probably on the occasion of its exhibition, from where it entered the State collection with his bequest.

Later Renoir described how his friends had helped him to carry the canvas to and from the dances and, though it was partially painted on the spot (as emphasized by Rivière), Renoir also made various preliminary studies. The framing of the scene, in which the figures at the sides are cut off, gives the impression that it continues beyond its bounds and that this is thus a slice of reality. The light brushwork is an extension of that used by Renoir in his smaller works, and, in particular, he has captured the mottled effects caused by the light filtering through the trees. For example, the back of the man in the foreground and of the dress of the woman seated next to him are marked by spots of coloured light, while the ground by Margot and Solares y Cárdenas is fragmented into areas of pink and blue. These unusual features were criticized by some in the reviews of the Third Impressionist Exhibition of 1877 at which it was displayed.

Both Rivière and Renoir admired the way in which the young workers who attended these dances managed to put aside their cares for its duration, and Rivière was keen to present the painting as a genuine scene of Parisian life. However, the very description he gave of the figures shows this to be somewhat untrue: the work is in many ways contrived and largely populated by Renoir's middle-class friends, who are enjoying the company of the lower-class girls — the image of carefree enjoyment is essentially an ideal.

33

PIERRE AUGUSTE RENOIR (1841-1919)
The Swing

1876. Oil on canvas, 92 x 73 cm. Paris, Musée d'Orsay

Like *Dance at the Moulin de la Galette*, this work was shown at the Third Impressionist Exhibition of 1877. Encouraged by Renoir, Rivière published a journal entitled *L'Impressioniste* for the exhibition. This was designed to defend the Impressionists against hostile criticism and appeared each Thursday for the month-long duration of the exhibition. On the cover of the third issue was an engraving of *The Swing* after a pen-and-ink drawing by the artist. The painting was executed in Renoir's garden at the house he rented in the Rue de Cortot in Montmartre, the location of a number of other works of this period. It is not clear who the models were, but it is suggested that the woman is either the Montmartre actress Jeanne Samary, or the model Margot, while the two men may be Renoir's brother Edmond and Norbert Goeneutte – both Goeneute and Margot appear in *Dance at the Moulin de la Galette*. Renoir here depicted similar light effects to those in the latter work: the ground is dappled with spots of light, as is the back of the man in the foreground. This painting is, however, more intimate in tone: the scene is one of quiet enjoyment, with the three figures chatting while a child looks up to them. The child adds an innocent, untrammelled air to the work and distinguishes it from those of, for example, Manet, which are the expression of a much more detached, incisive vision. As in other works, Renoir here creates an artificial world from which the everyday has been banished. Indeed the spirit is much the same as that of such eighteenth-century French painters as Watteau, Boucher and Fragonard, artists who Renoir greatly admired and whose works were then enjoying a revival of interest. Rivière made just this connection in one of his reviews, stating that 'one must go back to Watteau to find a charm analogous to that which marks *The Swing*'.

ALFRED SISLEY (1839-99)
Flood at Port-Marly

1876. Oil on canvas, 60 x 81 cm. Paris, Musée d'Orsay

This is the largest of a series of seven works that Sisley painted of the event in February 1876, the entirety of which represents one of his finest achievements. He had painted three other works of the same subject in 1872, and pictures of floods appeared later in 1876 as well. Port-Marly is a village on the Seine, close to Marly-Le-Roi, where Sisley was then living. The works in the 1876 series were all painted in the same area of the village, though each from different viewpoints. This work is an exception in that there is a smaller pair to it, also in the Musée d'Orsay. The painting depicts the flood at its greatest extent, the water on the left covering the road that divides the inn shown from the one on the opposite side, where Sisley set up his easel. Apart from the few boats with figures to the right of the 'A Saint-Nicolas' inn, the picture deals only obliquely with the human effects of the flood and is concentrated instead on the appearance of the landscape it creates. The large expanse of blue/grey, clouded sky is executed in blended brushstrokes, and flattens the composition as well as making the building stand out more starkly. Verticals formed by the building, trees and telegraph pole structure the composition. The water itself is painted in discrete strokes that are more varied in colour, though the flat, central area that merely reflects the sky leads the eye into the background, giving an impression of the extent of the flood. The dark, empty doorway acts as both a fixed visual point and emphasizes the near absence of human activity. Of the seven works, this was the only one to be exhibited in the artist's lifetime, at the Second Impressionist Exhibition of 1876.

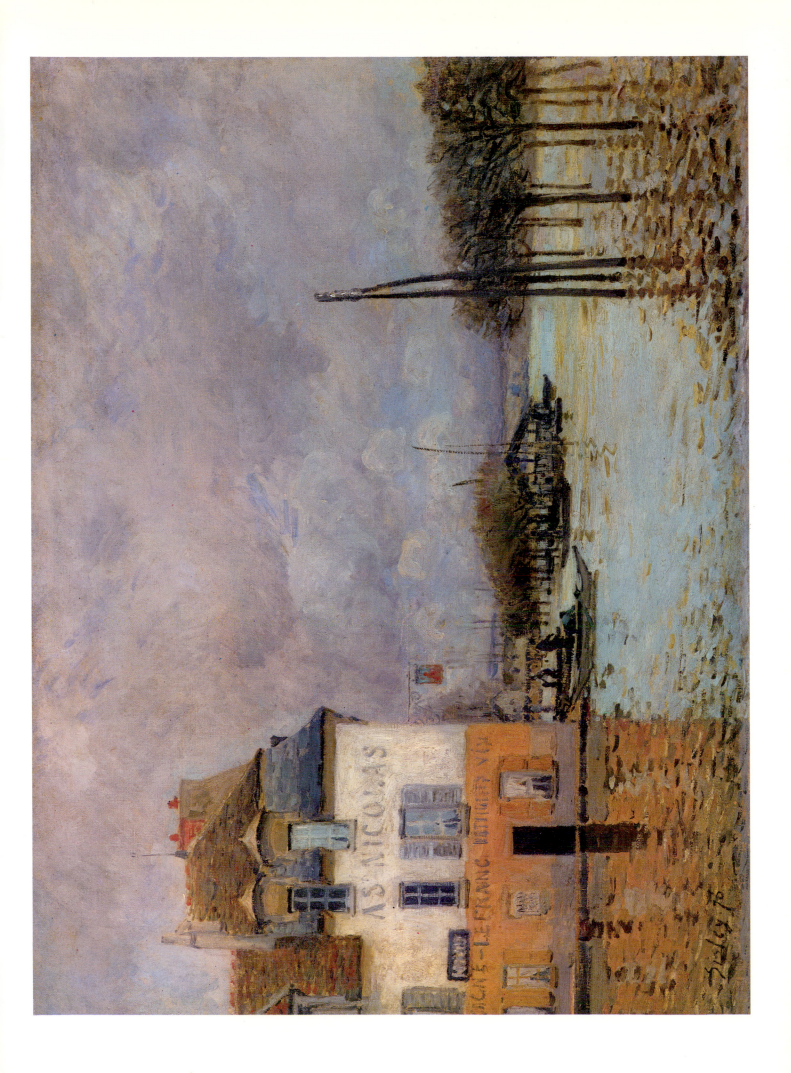

EDGAR DEGAS (1834-1917)
The Star

1876-7. Pastel over monotype on paper, 58 x 42 cm. Paris, Musée d'Orsay

Though he had used it before, Degas turned to pastel in earnest at about the time of this work, and it then became his favourite medium. This is one of the first examples in which the pastel was added over a monotype, a printing technique he had only recently learnt. Made by incizing or smudging away greasy ink on a metal plate and then printing through a press, the monotype method can actually produce two images, the first much darker than the second. Thus there is a variant to this work with dancers added to both the background and foreground. This pastel shows a prima ballerina making her exit bows, while her 'promoter' waits in the background among the sets, together with the other dancers. The severe downward angle suggests that the viewpoint is from one of the higher boxes. The composition is notable in that a large expanse of empty stage is left, providing a foil to the figure of the ballerina, brightly lit from below by the footlights. The background sets are only roughly sketched with swirls of pastel colour, again to avoid distracting from the centre stage. At the Third Impressionist Exhibition of 1877 Degas showed another pastel on the subject of ballet together with this one. Georges Rivière, in his review in *L'Impressioniste*, remarked to his readers that 'After having seen these pastels, you will never have to go to the Opéra again'.

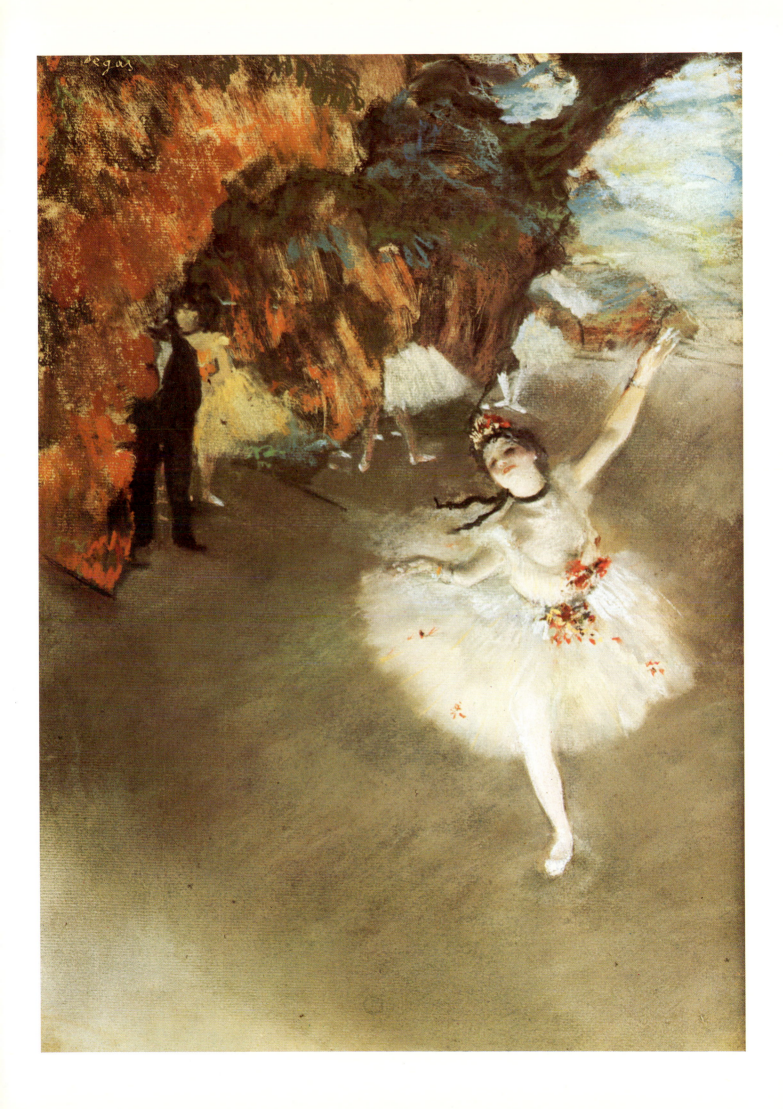

CLAUDE MONET (1840-1926)
The Gare Saint-Lazare

1877. Oil on canvas, 75 x 104 cm. Paris, Musée d'Orsay

Fig. 29
Monet
Gare Saint-Lazare:
Signal
1877. Oil on canvas,
65 x 82 cm. Private
collection

Between January and April 1877 Monet painted a series of 12 views of the Gare Saint-Lazare in Paris, both inside and immediately outside the station. These focus on the building itself and the trains, subjects that until then had received little attention in art. The Gare Saint-Lazare had been substantially reconstructed in the early 1860s and the structure shown here was one of the results of this work. Its huge expanse spans the composition, the central peak of the roof being exactly at the middle of the canvas, while to the right can be seen the slender iron column that supports it. The seemingly lightweight, airy quality of the building is enhanced by the large skylights at the top. The architectural features provide a geometrical armature for the work, which also includes the network of girders on the left and the parallel lines of the roof braces overhead. Further, the sun shining through the skylights throws a rectilinear pattern of light and shadow onto the track area of the foreground.

Despite the impressive scale of the building, the billowing blue smoke from the engine and the other clouds of steam soften its contours and fill the space. The engine itself is cloaked in steam and smoke, making it less a symbol of speed and power than an almost immaterial form. In the foreground is a rail worker, and along the right are people waiting for trains. The strong sunlight picks out buildings in the background, while bathing the image in a golden glow. At least seven of Monet's works from this series were shown at the Third Impressionist Exhibition of 1877, and these formed the centrepiece of his contribution. In his review in *L'Impressioniste* Rivière suggested that the works conjured up the 'noise, screeches and whistles' of the station and the 'shouts of the workers', though he nevertheless felt forced to admit the 'monotony and aridity of the subject', an indication that he too found it difficult to accept technology as a subject for art. Even more uncompromising is Monet's picture from the same series showing one of the signals of the Gare Saint-Lazare (Fig. 29).

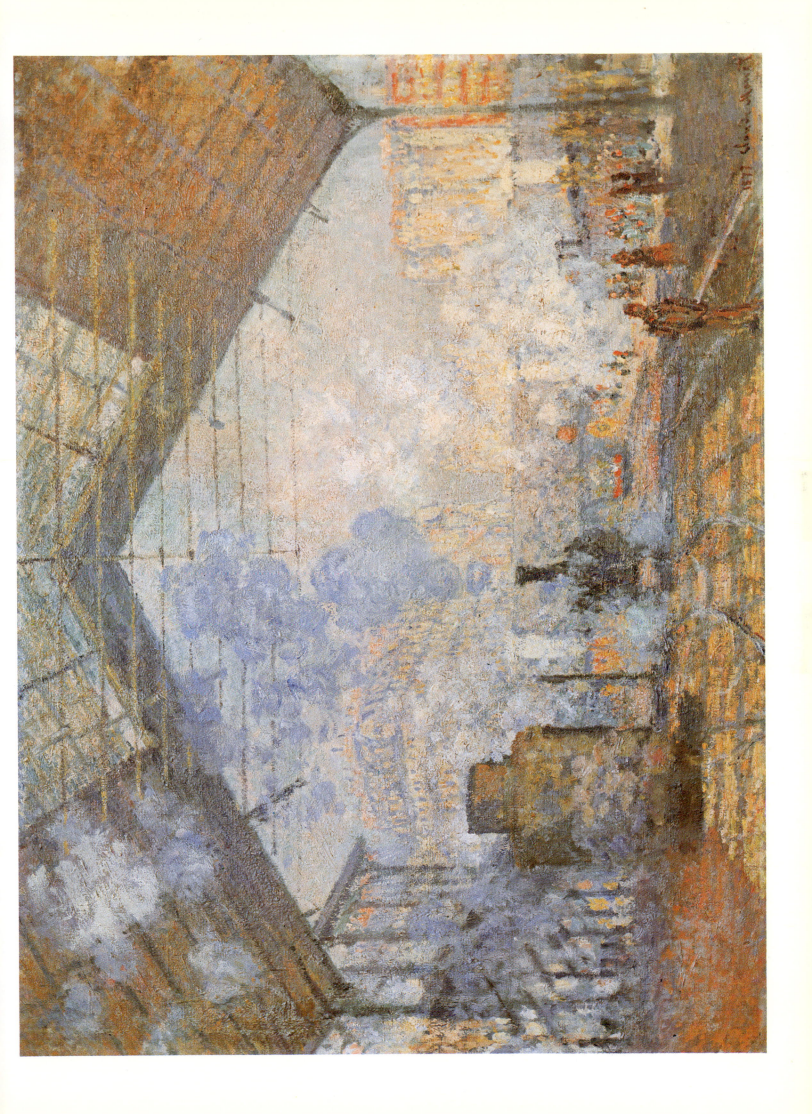

BERTHE MORISOT (1841-95)
Summer's Day

1879. Oil on canvas, 46 x 75 cm. London, National Gallery

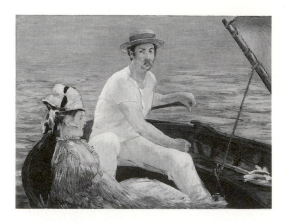

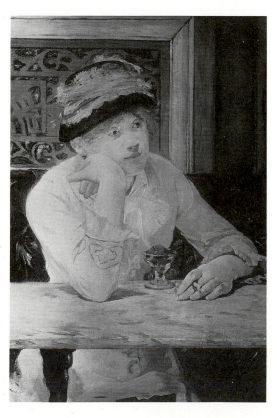

This work shows one of the lakes in the Bois de Boulogne in Paris, which had been radically altered between 1852 and 1858. Its long allées were replaced by a more 'natural' design inspired by the parks of London. Because of its proximity to the fashionable west side of the city, it became popular with the middle and upper classes. This picture, shown at the Fifth Impressionist Exhibition along with two other works set in the Bois de Boulogne, is inspired by Manet's *Boating* (Fig. 30), which was painted at Argenteuil in 1874. (Morisot was a close friend of Manet and married his brother, Eugène, in 1874.) As in Manet's work, the two figures are seen from a close viewpoint that suggests the artist is on the boat itself. The work also shares with Manet's an ambiguity with regard to the relationship between the two figures: seated well apart, one looks out at the viewer, while the other is absorbed in the activity of the river. The model for the figure on the right was apparently the same as that Manet used in his painting *The Plum* (Fig. 31).

Morisot here used extremely free brushwork, to an extent that distinguishes her from her Impressionist colleagues. The two figures are depicted in large, very visible brushstrokes, especially in the near foreground, and the criss-cross pattern of strokes tends to fragment their outlines, blending them with the background. The face of the figure on the left lacks any distinct features and her hand dissolves away into the side of the boat. This freedom is also adopted for the painting of the water ripples and is perhaps most extreme in the execution of the group of swans swimming alongside the boat to the right: even from a distance they do not merge into enclosed forms.

Fig. 30 (Top)
Manet
Boating
1874. Oil on canvas,
97 x 130 cm. New York,
Metropolitan Museum
of Art

Fig. 31
Manet
The Plum
c.1878. Oil on.canvas,
74 x 50 cm. Washington
DC, National
Gallery of Art

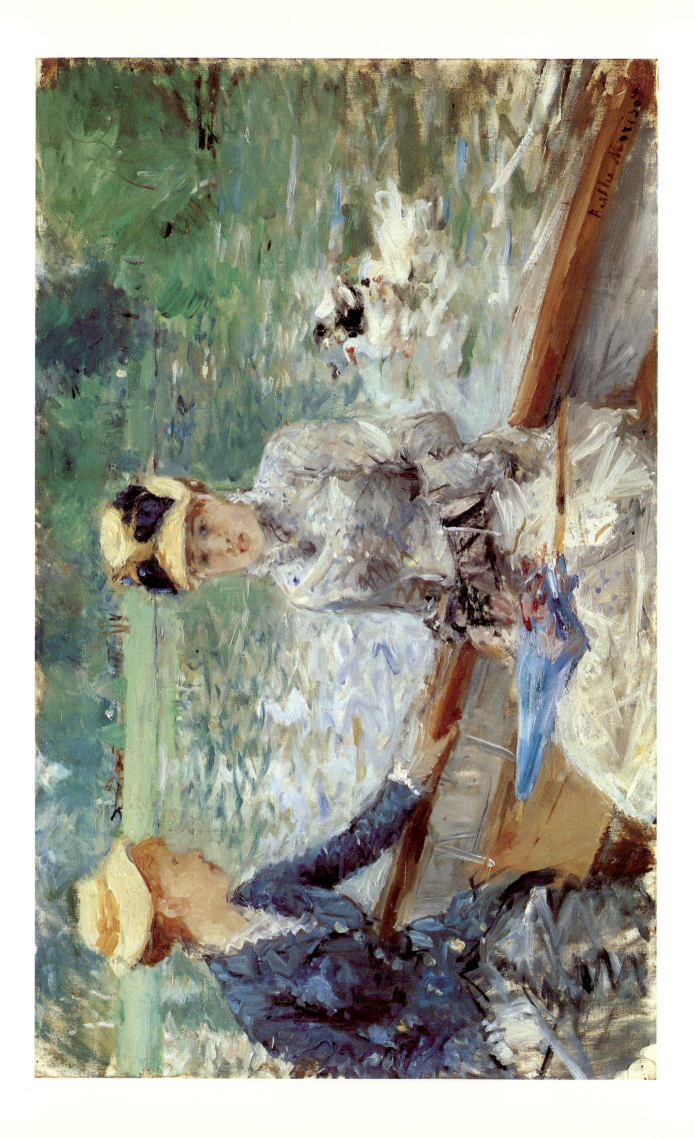

MARY CASSATT (1844-1926)
Five o'clock Tea

1880. Oil on canvas, 65 x 93 cm. Boston, Museum of Fine Arts

In the late 1860s the American Mary Cassatt received an informal academic training under Gérôme, Couture and others in Paris. It was not until the late 1870s that she became associated with the Impressionist group, through Degas, whose work she particularly admired. Under the influence of the Impressionists she began to reject both her academic subject-matter and mode of execution. She first showed with the group at the Fourth Impressionist Exhibition; this painting was shown at the Fifth Exhibition of 1880. The carefully observed domestic scene is a typical subject in her work and shows the Impressionist concern with the everyday. It is set in the Cassatt apartment in Paris (the family settled in Paris in 1877), with the family heirloom, the silver tea service, prominently placed on the table in the foreground. The figure on the left is probably modelled on Cassatt's sister Lydia, to whom the artist was very close, and next to her is a guest, as is made apparent by her more formal, upright pose. Though the two women are not engaged in conversation, there are probably no other figures in the room as only one other cup is visible. Like other scenes by Degas and Manet, the figures are treated in a detached manner and show no real signs of interaction. Lydia looks across the room in front of her guest, who, perhaps out of politeness, busies herself with her cup. The subject-matter of this work was thought distinctively British by French contemporaries. The artist also made an etching of one of the studies for this work.

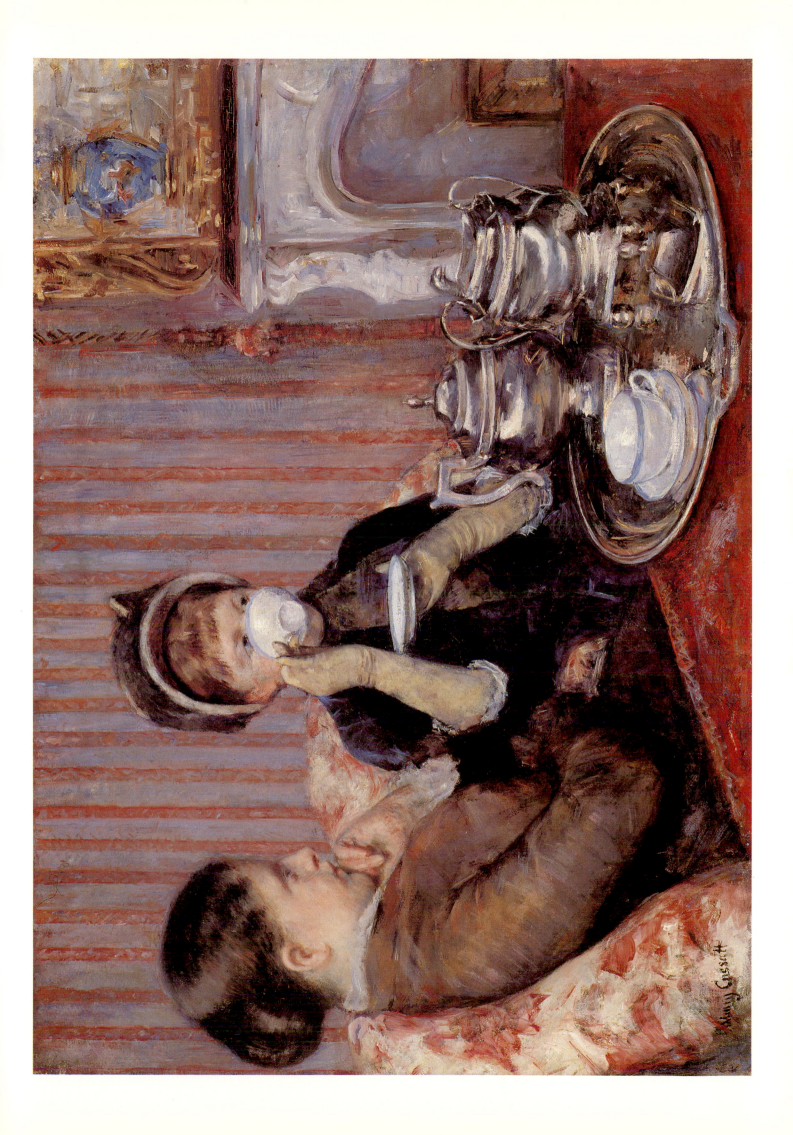

PIERRE AUGUSTE RENOIR (1841-1919)
Luncheon of the Boating Party

1880-81. Oil on canvas, 130 x 173 cm. Washington, DC, Phillips Collection

Begun in the late summer of 1880, this large work is a sequel to *Dance at the Moulin de la Galette* of 1876 (Plate 32) and treats the same subject as a smaller scale work of 1879-80. The location is the Restaurant Fournaise on the island of Chatou in the Seine, west of Paris, and was a popular meeting place for rowers. The models for several of the figures can more or less be certainly identified. Standing on the left is the restaurant owner Alphonse Fournaise and on the chair next to him, with a dog, is Aline Charigot, later Renoir's wife. Seated in the right foreground is Caillebotte, while to his left is possibly the model Ellen Andrée or the Montmartre model Angèle, with the Italian journalist Maggiolo. The top-hatted figure in the background is the rich collector and amateur writer Charles Ephrussi. Leaning on the terrace is possibly Fournaise's daughter Alphonsine, talking to Baron Raoul Barbier, an ex-cavalry officer and friend of Maupassant as well as of Renoir. In the right-hand corner are Renoir's friends, the journalist Lhote (in the straw hat) and the government official Pierre Lestringuez.

In contrast to *Dance at the Moulin de la Galette*, this work is much more strongly composed and modelled. There are fewer figures and each is more individualized, and the whole is set in a more enclosed space. Renoir constructed various visual links between the elements, for example, through the similar outfits of Fournaise and of Caillebotte, and through the scattered straw hats and the accents of red on various details. Space is also compressed such that the foreground figures are disproportionately sized in comparison with those in the background. However, this structure serves only pictorial ends: Renoir makes no attempt to forge any narrative links between the characters as would traditionally have been expected of a genre scene. In execution, the painting shows Renoir moving away from the open air light effects of *Dance at the Moulin de la Galette*. Filtered through the awning, the light is diffuse and largely uniform leading to none of the mottling effects of the earlier work. With the richly painted still-life of the foreground, the picture has resonances with Renaissance and Baroque banquet scenes, and communicates a sense of relaxed, convivial enjoyment.

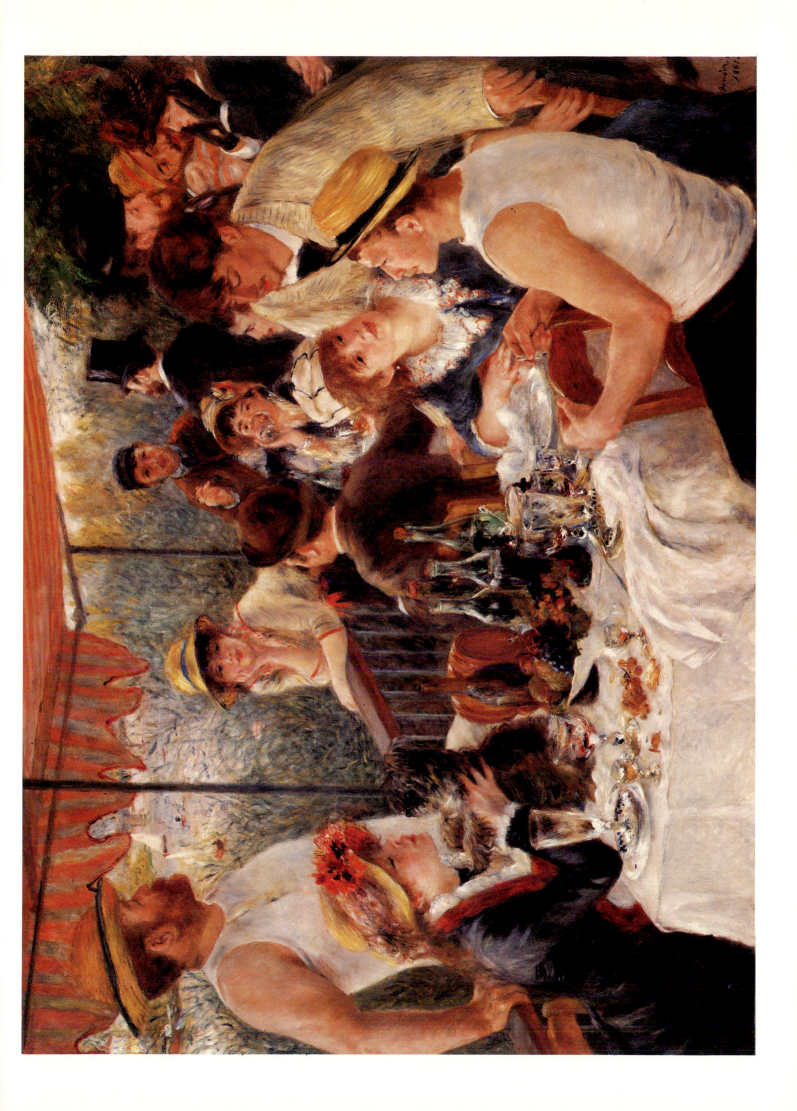

EDOUARD MANET (1832-83)
A Bar at the Folies-Bergère

1881-2. Oil on canvas, 93 x 130 cm. London, Courtauld Institute Galleries

This is Manet's last great masterpiece, painted at a time when he was already ill and finished a year before his death. It depicts a scene at the highly fashionable café-concert, the Folies-Bergère. Cafés-concerts flourished at this time and were places where one could drink and socialize as well as see circus acts, operettas and the like on the stage. Manet made a number of sketches at the Folies-Bergère, but actually painted this work in his studio. The central female figure was modelled by a girl called Suzon, who worked at the Folies-Bergère, while the man on the right was posed by the painter Gaston Latouche. Other figures in the reflected balcony are also identifiable. As was immediately noticed by the critics at the Salon of 1882 the depiction of the reflections in the mirror that runs the entire length of the background, parallel to the counter, are incorrect in naturalistic terms. The girl's reflection is shifted too far to the right, while the reflected image of the man is such that he ought to be seen in the foreground, somewhere between the viewer and the barmaid. The bottles reflected to the barmaid's left should be on the near, rather than the far, side of the mirror-image counter. Comparison with an oil study (Amsterdam, Stedelijk) shows that Manet deliberately changed his original composition in order to achieve this effect. He also altered the figure of the barmaid such that she appears in a more frontal and direct manner.

Many of those who attended the Salons, would have thought barmaids to be of dubious character, offering themselves, as well as drinks, to prospective clients, and this caused the familiar criticism that the work depicted something unseemly. In fact, however, the expression of the barmaid is melancholy and indifferent, rather than enticing, though by contrast, her reflected image leans forward in a more forthcoming way. The subdued emotion that she communicates may suggest the deadening effect of commercialism, in which human affection is a commodity like any other. It has often been suggested that by the distorted optics of the work Manet meant to imply that the viewer was the original of the man reflected: the responsiveness of the barmaid in reflection may thus have been intended as an enactment of male desire. The way Manet painted Suzon, more solid and modelled than the other figures, makes her dominate the work. The reflected figure of the man she serves is much sketchier, while those in the balconies behind are very loosely brushed and lacking in individual features. So as to maintain this focus, the activity in the rest of the composition is deliberately marginalized: for example, at the top left we see only the cut-off lower half of a trapeze artist. The only other element of the work that attracts the eye so quickly is the still-life on the counter, one of Manet's finest, with its richly painted arrangement of bottles, fruit and flowers. This equivalence of treatment highlights the ambiguity as to what the barmaid offers for sale.

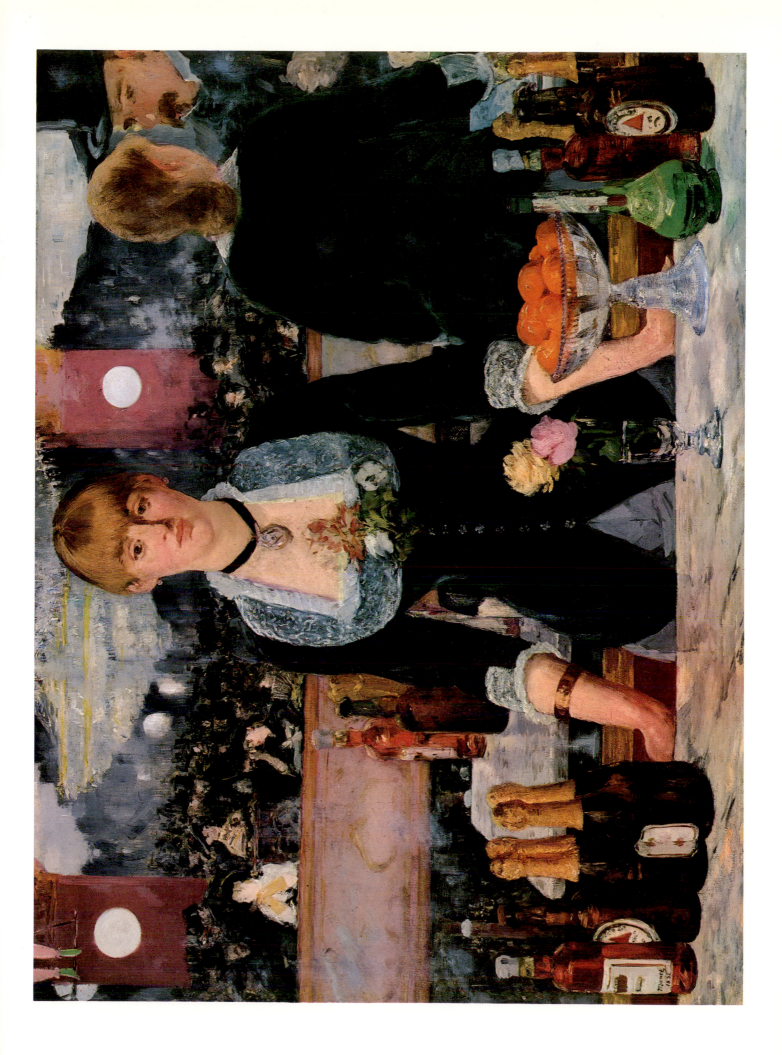

PIERRE AUGUSTE RENOIR (1841-1919)
The Umbrellas

c. 1881-6. Oil on canvas, 180 x 115 cm. London, National Gallery

This work is painted in two different styles: the earlier part, which includes the figures on the right, was probably painted in 1881-2, while the left hand side, with the foreground couple, was painted in 1885-6. This protracted period of execution is typical of Renoir's works of the 1880s, though the lack of a uniform style is unusual. Further evidence for the respective datings is provided by the different fashions of the dresses (Renoir was generally accurate in such matters in his large modern life scenes). The right-hand figures are painted in light, feathered brush-strokes, which are characteristic of the artist's earlier Impressionist style, as are the sweet smiles of the child and woman. However, the two figures on the left, modelled on Aline and Lhote, are painted in a much harder and firmly structured manner that to some extent resembles Cézanne's planar style (Fig. 25). The latter affected other of Renoir's works of 1885-6 and the influence of Cezanne's so-called 'constructive stroke' is especially evident in the painting of the trees in the background. Except for the more varied colour scheme of the left hand foreground figures (particularly the orange of the girl's hair), the palette is dominated by cool blue tones.

While the people in the crowd busy themselves with their umbrellas (which create a rigid structure in the upper part of the work) the young woman on the left and the child to the right both look directly out at the viewer, the former with a rather pleading expression. As they do so, the young man in turn stares intently at the woman, perhaps about to offer her the shelter of his umbrella, or maybe just admiring her. This is the last of Renoir's large scale pictures of modern life. The disparity of styles and fashions, the latter being particularly apparent to contemporaries, made the painting hard to sell. Nevertheless, Renoir was for some reason unwilling to rework the earlier parts to create a more unified image.

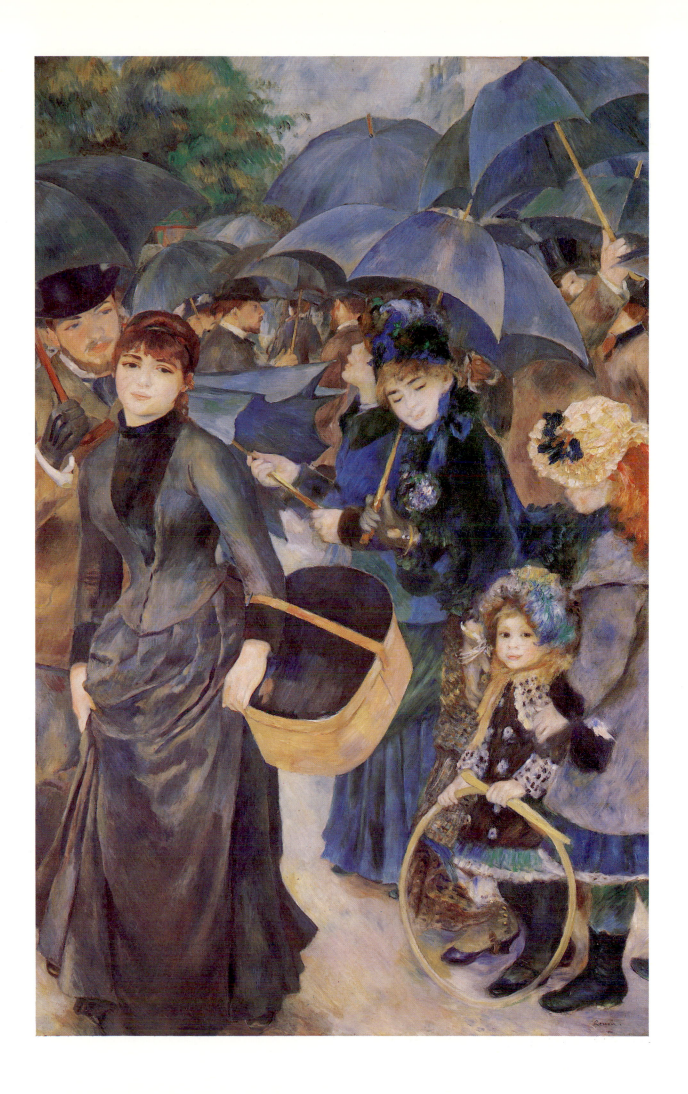

MARY CASSATT (1844-1926)
Two Women in a Loge

1882. Oil on canvas, 80 x 64 cm. Washington, DC, National Gallery of Art

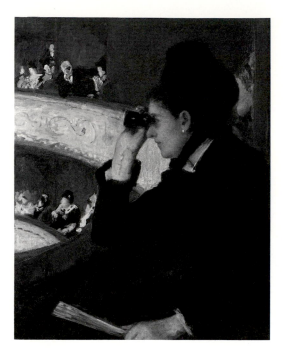

Fig. 32
Cassatt
A Woman in Black
at the Opera
c.1879. Oil on canvas,
80 x 65 cm. Boston,
Museum of Fine Arts

This is one of a series of works showing women in theatre boxes. The most accomplished of Cassatt's earlier treatments of this theme is *A Woman in Black at the Opera* (Fig. 32). In contrast to this latter painting, the figures in this work are much more formal and self-conscious. Clearly young adolescents, their stiff, upright poses suggest that they are making an effort to appear and behave correctly in public in accord with their polite upbringing. The close, overlapping forms of their bodies denote a certain intimacy between them, although they both look outwards. The two figures were modelled on Cassatt's friend Mary Ellison (who appears in other of her works) and Geneviève Mallarmé, daughter of the poet Stéphane Mallarmé, whom Cassatt knew. In comparison with Renoir's *La Loge* (Plate 25) there is no sensuality in either the poses or handling of the paint (the fabrics are drily and firmly modelled). While the right hand figure seems quite confident, her companion hides shily behind a fan and is seated further back. Her crossed, parallel arms add to this impression of defensiveness. The greater confidence of the woman on the right is further indicated by the detail and modelling of her posey of flowers, which contrasts with the cursory, more pallid decorations on the fan.

The arc of the fan unites the composition: by extrapolation it continues along the shoulder of the figure on the right while at the other end it is aligned with the elbow and hand of her companion. A mirror at the back of the loge reflects the balconies on the other side, and on the right one can see a partial reflection of the woman nearest it. The scene reflected indicates both that the theatre is a high class one and also that the women are seated in one of the more expensive lower boxes near the stage. The balconies add to the structure of curves that organizes the composition. The reticence of this image contrasts with that of *A Woman in Black at the Opera* in which the woman looks casually through opera glasses at the other loges, playing the same game as the man in Renoir's *La Loge*. In the background of the Cassatt picture one man brazenly leans out to look at her in turn.

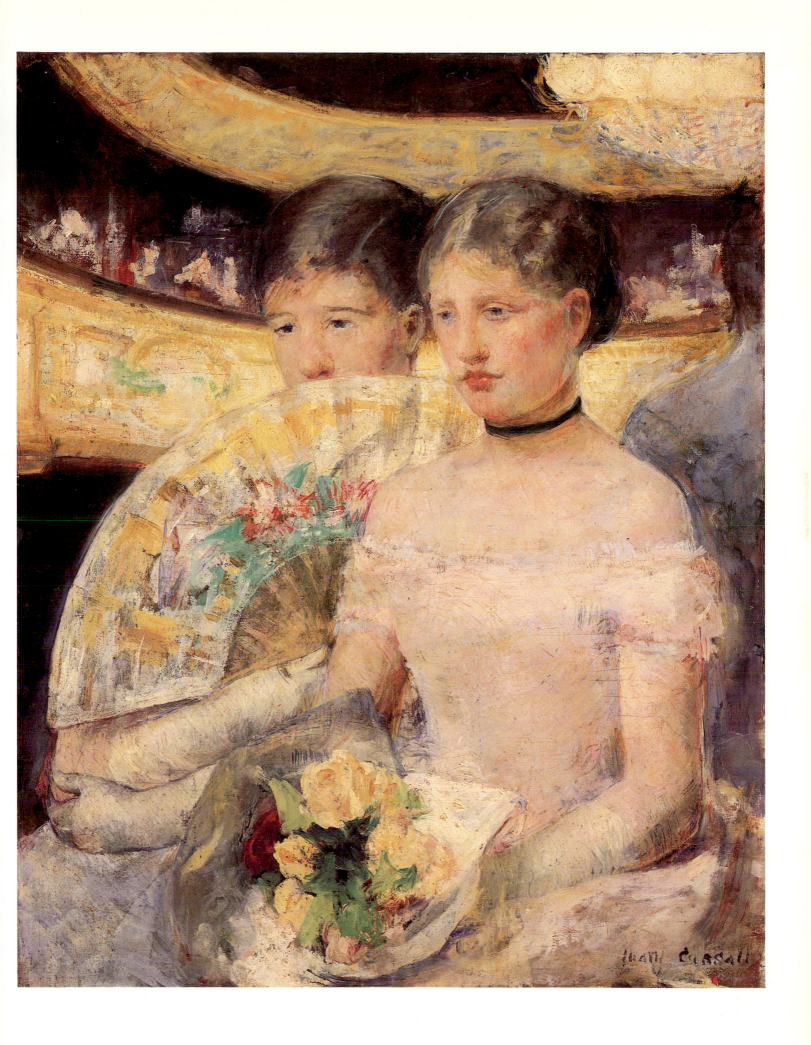

EDGAR DEGAS (1834-1917)
After the Bath

c.1883-4. Pastel and wash on paper, 52 x 32 cm. Private collection

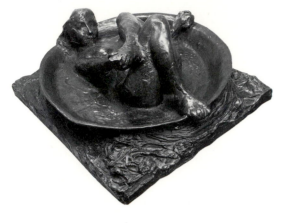

Fig. 33
Degas
Woman in a Tub,
1886. Bronze,
22 x 46 x 42 cm.
Edinburgh, National
Gallery of Scotland

In the second half of the 1870s Degas began producing a number of pastels of nudes washing, drying, dressing and so on, and these reached their full development in the 1880s. He showed a group of six or seven such pastels at the Eighth Impressionist Exhibition of 1886, where they received great critical attention. In some of the pastels Degas used overtly erotic poses and, though eroticism was doubtless one of the reasons for his choice of this theme, another equally important motivation was the new forms that the subject presented him. This interest in form even led him to attempt similar subjects in sculpture (Fig. 33). In pose and scale this work represents the transition from those of the late 1870s and early 1880s to those of the late 1880s. In contrast to the earlier examples, it is larger and shows the figure upright rather than crouching, seated or bent over. Degas added an extra strip at the bottom of the work to allow himself room for this pose. As here, most of the figures in the series have their backs to the viewer, so giving the impression that they are caught unawares, engaged in activities that normally remain concealed. The poses, sometimes rather ungainly, were unusual in art, though on occasion they mimic those of classical statues. As in some of the images of dancers, the figure here is shown precariously balanced on one leg while drying the other. The lighting from the half-open window emphasizes her form, making it almost sculptural, and there is little in the interior to distract from the central figure. In fact, the flat, decorative areas of the bathrobe, curtain and wall covering form a backdrop against which her three dimensionality is displayed to greater effect, while the rich, dark colours of these elements offset the light flesh tones.

The reviews of the 1886 exhibition, which reflect the range of attitudes towards the works as a whole, were largely favourable and praised Degas' extraordinary draughtsmanship. The voyeuristic feel of these works was noted: Degas himself said that the nudes were seen 'as if through a keyhole'. As ever questions were asked about the status of women depicted, though perceptions were various. Many saw them as lower class, perhaps even prostitutes, a reading that was thought to be confirmed by the fact that the figures were not ideal in the academic sense. Some contemporaries also suggested that the lack of grace in the poses of the figures and the realistic portrayal of such intimate activities were signs of misogyny on Degas' part. However, in the late 1880s and 1890s misogynistic views of women were prevalent in Decadent literature, and such comments probably reflect more about the critics than the artist, though the view persists to a degree.

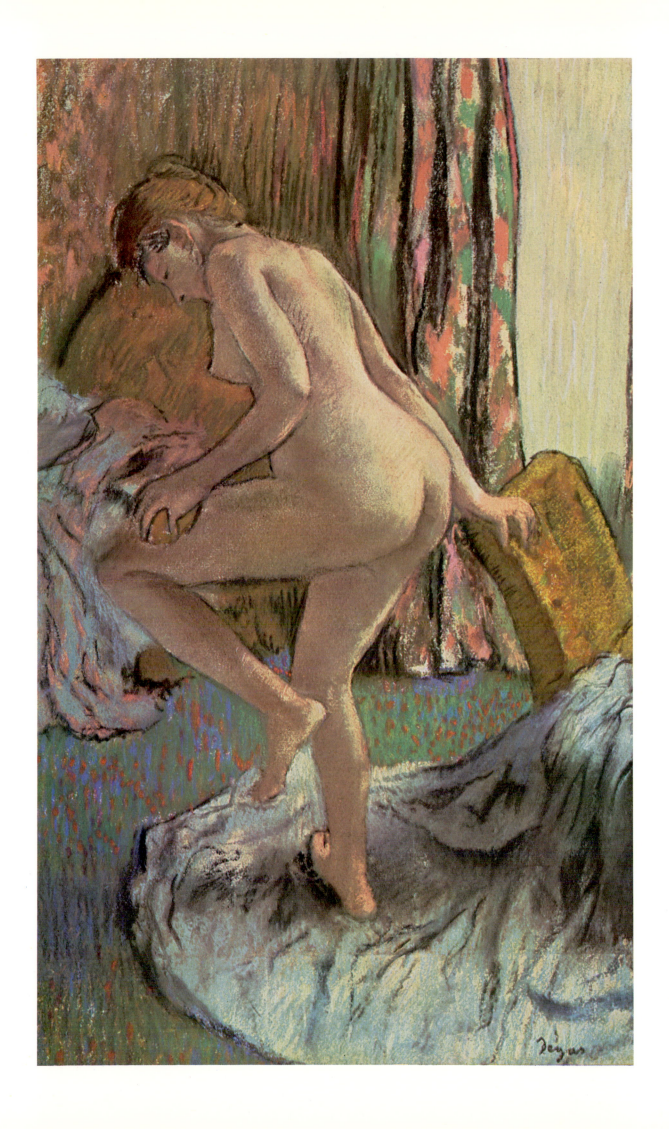

CLAUDE MONET (1840-1926)
Grainstacks, End of Summer, Morning Effect

1890-91. Oil on canvas, 60 x 100 cm. Paris, Musée d'Orsay

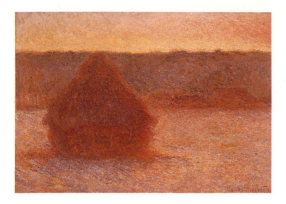

Fig. 34
Monet
Grainstacks at Sunset:
Frosty Weather
1890-91. Oil on canvas,
65 x 96 cm. Private
collection

Though sometimes incorrectly called haystacks, the structures shown here are grainstacks, which were made by enclosing ears of grain in a coating of hay to protect them from the weather. The grainstack works of 1890-91 formed the first of Monet's series, though he had painted a handful of works of the same subject in 1889. Consisting of 25 canvases in all (see also Fig. 34), they were probably begun in August or September 1890 and were largely finished by February 1891; an exhibition of 15 of them was held in May 1891. The works were all painted near Giverny, where Monet had settled in 1883, and the series developed as he realized that he could not properly capture the light and atmospheric effects of the subject with only a few canvases. Some show one stack, some two and there are three paintings in which Monet depicted one stack from such a close viewpoint that the form is cut off by the frame. While the works were begun on the spot they were finished in the studio. In the background of each appears a more or less detailed landscape, with trees and farm buildings.

Though often described in terms that suggest that Monet was concerned only to depict what he saw before him, individual and comparative studies of the works shows that he in fact altered the composition in some cases for purely pictorial ends. Likewise the colouring and arrangement of some of the light effects seem to have been enhanced on occasion. At the time that they were painted the rural subject-matter of the works was very topical as it tied in with contemporary assertions about the value of the French countryside and its agriculture. Industrially overshadowed in Europe by her enemy Germany as well as by Britain, national sentiments began, instead, to attach to the land and its people. Thus, in Monet's paintings the farm buildings of the workers who had built the grainstacks are perfectly integrated into the landscape, suggesting the harmony of their lifestyle.

The series of 15 works exhibited in 1891 were very well received and substantially contributed to Monet's growing reputation as one of France's foremost painters. His success at this time caused some resentment among his Impressionist colleagues, whose works were eclipsed as a result. Pissarro saw the grainstacks series as being primarily motivated by commercial concerns, designed merely to satisfy the demand for works of this subject. He was nevertheless aware of their quality and had to admit that Monet was 'a very great artist'. The series was widely influential on early twentieth-century artists: Kandinsky, for example, saw them as being the first abstract works as they showed a dominance of form over subject-matter.

CLAUDE MONET (1840-1926)
Rouen Cathedral, Façade (Morning Effect)

1892-4. Oil on canvas, 100 x 65 cm. Essen, Folkwang Museum

Fig. 35
Monet
Poplars: Wind Effect
1891. Oil on canvas,
100 x 73 cm. Private
collection

Between 1892 and 1895 Monet painted a series of 30 views of Rouen Cathedral, which followed the *Poplars* series of 1891 (Fig. 35). He knew Rouen well as he had painted there several times in the 1870s. However, this was the first time that he had made such a concentrated study of an architectural motif, and his choice of the cathedral was significant. In the early 1890s France was experiencing a wave of renewed interest in both Catholicism and other religions. Furthermore, Gothic architecture had a distinctly nationalist resonance as it recalled a time when French culture dominated Europe, with the style spreading widely abroad. As Ruskin had earlier claimed, Gothic buildings were also seen as the products of a more integrated, harmonious society than those of later periods, and were viewed as truly communal achievements. The city of Rouen was itself of national importance, being, for example, the place where Joan of Arc was burnt at the stake.

Having started to paint the series in a rented room opposite the cathedral, Monet's viewpoint changed with the location of his lodgings, and four different vantage points can be discerned in all. His proximity to the subject gives the works a peculiar cropped composition and almost a sense of claustrophobia, allowing him to include only parts of the façade, and fragments of either the Tour d'Albane to the left or the Tour de Beurre (or Tour Saint Romain) to the right. Though the ostensible subject-matter is the cathedral, as in the other series works, Monet was as much concerned with the problem of recording the changing light and atmospheric effects, from morning to evening. This work shows the blue tinge of the weak morning light, which picks out the upper details of the façade in orange and gold, while the majority of the structure seems almost dematerialized in a ghostly haze.

During the protracted period of the series' execution Monet frequently became despondent, feeling the results both slight and unworthy, and between his campaigns of work he took on other projects also. His tenacity always carried him, however, and he once asserted 'I will do the impossible and it will work'. Monet's insistent interest in a single theme or object in the series paintings can be linked to the Symbolist theories propounded by his friend, the poet Stéphane Mallarmé. For the Symbolists reality was inherently elusive and impossible to grasp in full: an object could be described only partially, but something would always be lost. In the series works it is as if Monet was endlessly engaged in a frustrating attempt to record the true nature of his subject, while implicitly acknowledging that it would constantly evade him.

CAMILLE PISSARRO (1831-1903)
The Pont Boïeldieu, Rouen

1896. Oil on canvas, 74 x 92 cm. Pittsburgh, Carnegie Museum

In 1883 Pissarro had painted a series of pictures of Rouen, which marked a move away from the preceding large figure works. This painting is one of a more substantial series of the city that he executed during three campaigns in 1896 and 1898. He exhibited the results of the first campaign (January to April 1896) at Durand-Ruel's soon after his return to Paris, and their success was such that the dealer paid for another trip from September to November of that year, the two trips resulting in 28 pictures. The third campaign, from July to October 1898, led to another 19 works. This picture was probably painted during the second visit. Pissarro's decision to work at Rouen again was doubtless largely prompted by the success of Monet's paintings of the cathedral (1892-5; see Plate 45), but also by the fact that the city offered that mixture of old and new that so interested him. The series consists both of views of the medieval centre and of the bustling, modern docks, each showing differing effects of light and atmosphere. During the second of his visits Pissarro exclaimed that Rouen 'is as beautiful as Venice...it has an extraordinary character'.

Like that of 1883, this series also marked a change in Pissarro's style. After his flirtation with the techniques of neo-Impressionism in the late 1880s, he here returned to the transparent colours and light brushstrokes of Impressionism. The bridge that dominates this image is the one that appears most frequently in the series and was built in 1885 to replace an earlier suspension bridge. While some of the dock scenes are transformed by the warm glow of full sunlight or of sunset, this one is executed in the grey, subdued colours of an overcast day. The harshness of the scene is compounded by the smoking funnels and chimney. The chimney that rises high above the surrounding buildings, billowing thick black smoke, was part of a gasworks, and to its left can be seen the glass roof of the newly built Gare d'Orléans. This depiction of modernity and industry is animated by the workers in the foreground and the numerous figures dotted along the bridge. Despite its apparently unsightly features, in such works Pissarro saw himself as seeking out beauty in those places overlooked by others, as he once wrote to his son Lucien: 'One can make such beautiful things with so little'.

47 CAMILLE PISSARRO (1831-1903)
Boulevard des Italiens, Paris:
Morning Sunlight

1897. Oil on canvas, 73 x 92 cm. Washington, DC, National Gallery of Art

Following a series of street scenes of 1893, in 1897 Pissarro again turned to the capital for the subject-matter and at first produced a handful of scenes of the rue Saint-Lazare and rue Amsterdam. He then painted a more ambitious series of 14 views of the boulevard Montmartre plus two of the boulevard des Italiens, these latter being 'terribly difficult views' according to the artist. Based in the Grand Hôtel de Russie, he used one viewpoint for the boulevard Montmartre scenes and another for both of the boulevard des Italiens pictures. Like Monet in his series paintings, Pissarro wanted to capture the effects caused by changes in light and season and he even painted a night view of the boulevard Montmartre. In contrast, however, and at a time when the other Impressionists had mostly given up urban themes, Pissarro was also concerned with the human activity of the street: three of the boulevard Montmartre scenes show a Shrove Tuesday carnival filling the boulevard with tightly packed figures.

The cool, morning light of this work contrasts with the radiant illumination of its companion piece, which is filled with the raking glow of the afternoon. Here, the pavement, carriages and buses are crowded with people and the density of the figures allows little room for individualization. This anonymity is further enhanced by the uniform black clothing of most of the figures. The colour scheme of the work tends to blend the people into indistinct masses that merge with their surroundings: the dabs of colour on the trees are indistinguishable from those representing faces. The grandeur of the great boulevards of Paris is powerfully suggested by the way the buildings, with their regular architecture, rise above the street to the top of the picture, dwarfing the activity below. To a greater degree than can be found in other Impressionist images of the city, the works of Pissarro's series capture the energy and life of the streets. In their dynamism they look forward to the city paintings of the German Expressionists in the early twentieth century.

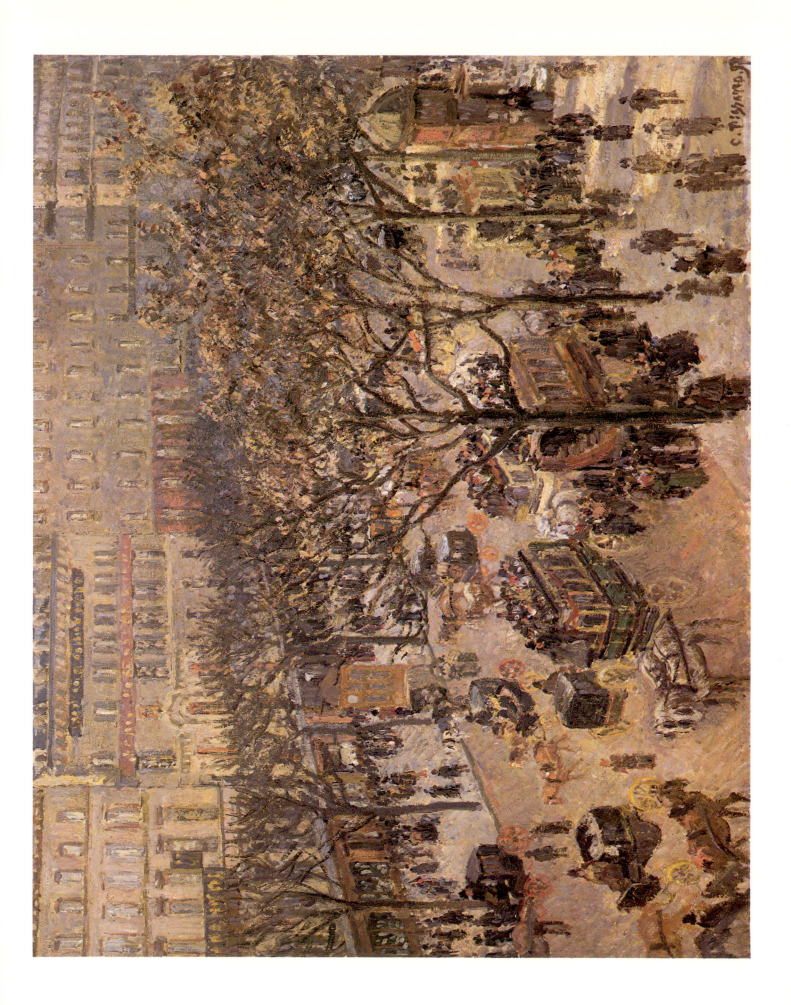

CAMILLE PISSARRO (1831-1903)
Place du Théâtre Français, Paris: Rain Effect

1898. Oil on canvas, 74 x 92 cm. Minneapolis, Minneapolis Institute of Art

In late 1897 Pissarro began a series of 15 pictures of views from the Grand Hôtel du Louvre in Paris, showing various scenes of the Place du Théâtre Français, the Avenue de l'Opéra and the rue St Honoré, and he finished the series in the spring of 1898. The year 1897 had been traumatic for him: his son Lucien had had a stroke and worse still, in November 1897 another son, Félix, had died of tuberculosis at the age of 23. The artist was also suffering from a recurrent eye infection, which had dogged him since 1889. Politically the years 1897/8 were especially unstable due to the Dreyfus affair, which had a particular relevance to Pissarro as, like Dreyfus, he was Jewish. The affair bitterly divided the Impressionists: Degas, for example, became fiercely anti-semitic and so his relationship with Pissarro suffered. Pissarro's response to all these events was to wrap himself up in his work and, though very politically minded, he seems to have kept his art and politics separate in these paintings. In the letter he wrote to Lucien, telling him of Félix's death, Pissarro mentions his new subject: 'I am delighted to be able to try to do these Paris streets, which are so often called ugly, but which are so silvery, so luminous and so lively'.

In this work the circular Place du Théâtre Français is in the foreground, from which the Avenue de l'Opéra branches off into the distance, Charles Garnier's opera house being visible at the very end, enveloped in a haze. This area of the city was filled with high-class shops and was the heart of consumerism in the capital. Here, as mentioned in his letter, he depicted the 'silvery' streets wet with rain. In contrast to the Boulevard Montmartre series of the previous year, these works presented Pissarro with a much more rectilinear composition, dominated by distant views in plunging perspective. Furthermore, there are the additional circular elements of both the Place du Théâtre Français itself and the pedestrian islands with their fountains. Pissarro thought this series a great success, and it was exhibited in its entirety at the Durand-Ruel galleries in June 1898.

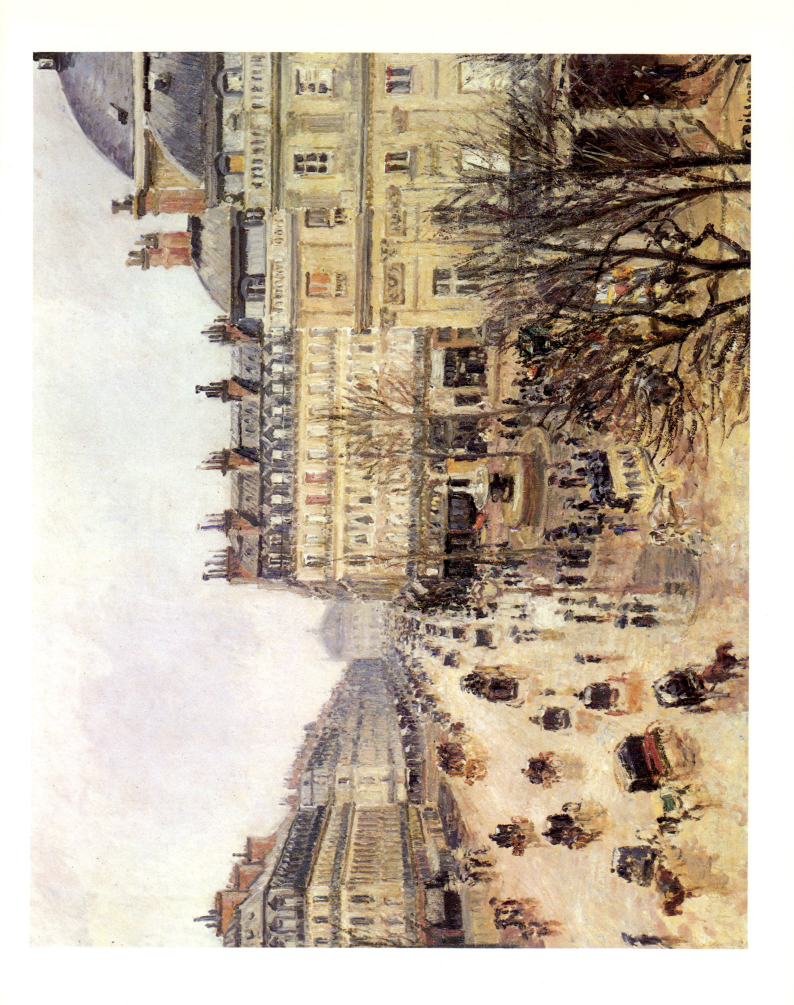